The Beautiful Wedding

Photography Techniques for
Capturing Authentic Moments

Tracy Dorr

AMHERST MEDIA, INC. ■ BUFFALO, NY

About the Author

Tracy Dorr is the author of *Engagement Portraiture: Master Techniques for Digital Photographers* and *Set the Scene: Use Props to Create Memorable Portrait Photography*. She holds a BA in English/Photography from the State University of New York at Buffalo and has been shooting professionally since 2003. She won three Awards of Excellence from Wedding and Portrait Photographers International (WPPI) and was a Master Class teacher at the WPPI convention in Las Vegas. Her work has been published in numerous local wedding publications and is on display in a number of local businesses. Tracy's work has also been published in six books in the *500 Poses* series by Michelle Perkins, on the subjects of brides, men, couples, groups, children, and infants and toddlers (Amherst Media). She lives in Williamsville, NY, with her husband Bill and daughter, Annaleigh.

Published by:
Amherst Media, Inc.
P.O. Box 586
Buffalo, N.Y. 14226
Fax: 716-874-4508
www.AmherstMedia.com

Publisher: Craig Alesse
Senior Editor/Production Manager: Michelle Perkins
Associate Editor: Barbara A. Lynch-Johnt
Editorial Assistance from: Carey A. Miller, Sally Jarzab, John S. Loder
Associate Publisher: Kate Neaverth
Business Manager: Adam Richards
Warehouse and Fulfillment Manager: Roger Singo

ISBN-13: 978-1-60895-715-6
Library of Congress Control Number: 2013952532
10 9 8 7 6 5 4 3 2 1

Check out Amherst Media's blogs at: http://portrait-photographer.blogspot.com/
http://weddingphotographer-amherstmedia.blogspot.com/

TABLE OF CONTENTS

WITHDRAWN

1. **A Fresh Mind-Set** 6
A Distinctive Style, Advancing Your Methods, Intuition

2. **The Basic Approach** 8
Working Unobserved, Equipment, Simplify!

3. **Two Photographers** 10
The First Shooter, The Second Shooter, Shooting Solo

4. **Preparing Clients** 12
The Educated Client, Cultivating Trust, Show Your Work

5. **Equipment vs. Artistry** 14
You're an Artist

6. **Emotion** . 17
Walk in Their Shoes

7. **Flattering Portraiture** 18
Perfect Moments, "Almost" Moments

8. **Self-Growth** 20
Review Your Past Work, Refine Your Image Presentation, High-Quality Materials

9. **Staying Ahead of Your Competition** 22
Self-Growth Keeps You Viable

10. **The Decisive Moment** 24
Henri Cartier-Bresson

11. **Work Fast, Shoot Smart** 26

12. **Your Best Shot** 28
Be Selective

13. **Preparation** 30

14. **Crowds** . 32
Learning to Wait

15. **The Receiving Line** 34
Practice, Watching and Waiting

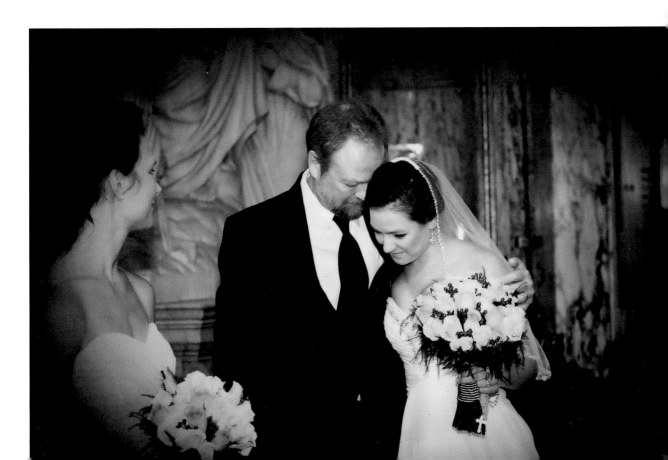

16. Environmental Portraiture 36
Zeroing In, Striking a Balance

17. Verbal Cues 38
*"I'm So Glad You Made It," "That Means
So Much to Me!" "Oh My God!"*

18. Body Language 40
Emotions Are Contagious

19. Traditional Moments 42

20. Subject Behavior 44
*Interactions, Identify Their Bond,
Mannerisms*

21. A Little Push 46
*Better Lighting and Backgrounds,
Authentic Experiences, Featured Images*

22. Preparations 48

23. Details: These Things Matter 51

24. Details: The Dress 52
*Critical Shots, Texture and Detail,
All That Glitters*

25. Details: Her Personal Effects 55

26. Details: The Flowers 56

27. Details: The Rings 58
The Unbreakable Vow, Tips for Success

28. Details: The Ceremony 60

29. Details: The Reception 62

30. Details: Found Objects 64

31. Key Shots: The Bride 66

32. Key Shots: The Groom 69

33. Key Shots: The Couple 71

34. Key Shots: The Wedding Party . . . 72
*Key Players, Individual Portraits,
Group Candids*

35. Key Shots: The Parents 74

36. Key Shots: Children 76

37. Key Shots: The Extended Family . . 78

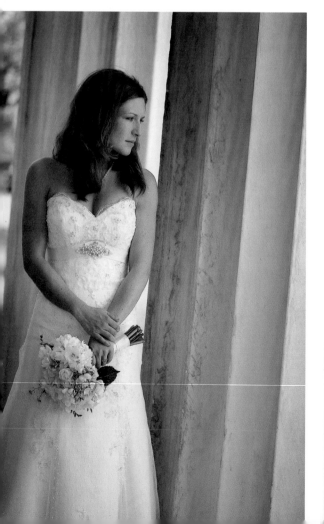

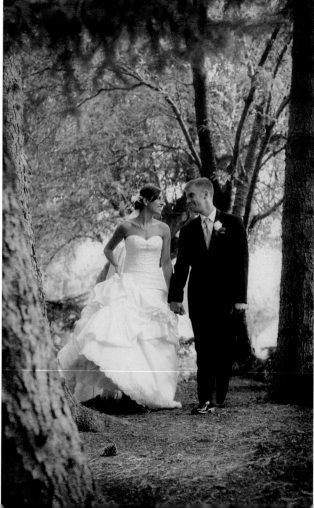

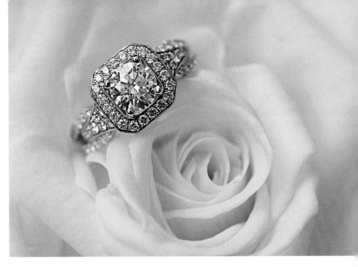

38. Natural Light 80
Zoom Lens Advantages 80

39. Mixed Lighting 82
White Balance, Flattering Skin Tones,
Postproduction

40. Composition 84

41. In-Camera Experimentation 86
Shoot More, Lenses, Framing,
Camera Angles

42. Finishing Touches 88
Back Up Your Original Files, Software Is
an Essential Tool, Actions,
Enhanced Images, Increased Value

43. Monotone Images 90
Capture in Color—Then Convert, The
Benefits of Black & White

44. Cropping . 92
Lose Extraneous Details

45. Special Effects 94
Go On, Experiment!

46. Fine Art 1 96
The Finishing Touch

47. Fine Art 2 99
Choosing Products, Get Creative!
Push Your Boundaries

48. Proofs Presentation 101
Efficiency, Present Polished Photographs,
Bring Your "A" Game

49. Expanding Your Reach 102
Friends and Family, Future Clients

50. Sales . 104
Comfort, Enthusiasm

51. A Gallery Look and Feel 107
Gallery-Inspired Presentation,
Appropriate Pricing, Get Inspired

52. Albums . 108
A Cohesive Look, Options, Software and
Design Templates, Storytelling,
Transitional Shots

53. Prints and Other Products 110
Wall Prints, Frames, Alternative Products,
Offer Your Expertise

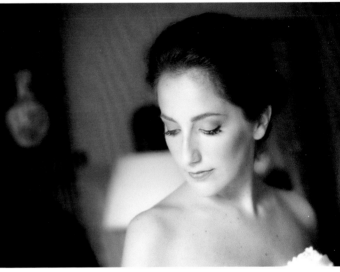

54. Build a Lasting Relationship 112

55. Expanding Your Business Focus . 114
Shared Characteristics, Intense Emotion,
Real Impact

56. Managing Distractions 116

57. Parent-and-Child Interactions . . . 118
Working Outdoors Is a Must, Fill Flash

58. Encouraging Activity 120
Push Through, Adding Props

59. Selling Children's Portraits 122
Customer Service and Sales,
Special Touches

Conclusion . 124

Index . 125

1 | A Fresh Mind-Set

Equipment: Canon EOS-1D Mark III with EF 70–200mm f/2.8L USM lens. Exposure: f/3.5 at $\frac{1}{200}$ second and ISO 200. Focal length: 110mm (top image) and 120mm (bottom image).

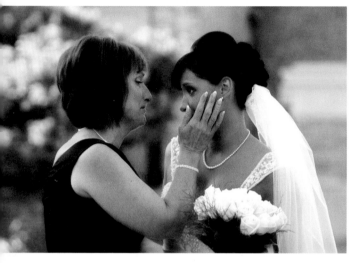

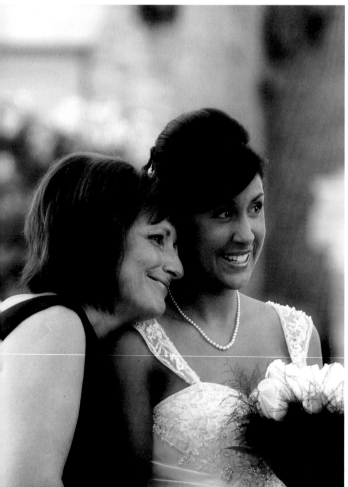

A Distinctive Style

Outstanding candid wedding photography is not a casual way of documenting the wedding. It is a highly skilled, painstaking way of approaching the event, where you will search for intimate, natural, and honest moments to capture. To achieve excellence, you will need to develop a discerning mind-set that allows you to capture images that have an intangible X-factor, which only comes from pictures that have elements working together in harmony.

Advancing Your Methods

The desires of the modern client are quickly evolving. To keep up, we photographers must flex our creativity and skill, pushing ourselves to meet a challenging set of higher standards. Photojournalism, a relaxed posing approach, and artistic editing are regularly requested by brides and grooms. They now want both the traditional and nontraditional merged together into a unique product for their important day.

If you want to increase your image sales, you need to adapt to the changing standards and learn to capture moments of real emotional resonance—to refocus your intent on capturing moments of interplay between people. We will be looking for moments that demonstrate the height of emotion and tell stories in innovative and touching ways. You are trying to create a piece of art that will last a lifetime for your client. Through practice, you will learn to create beautiful images that look polished enough to have been posed. Essentially, we have

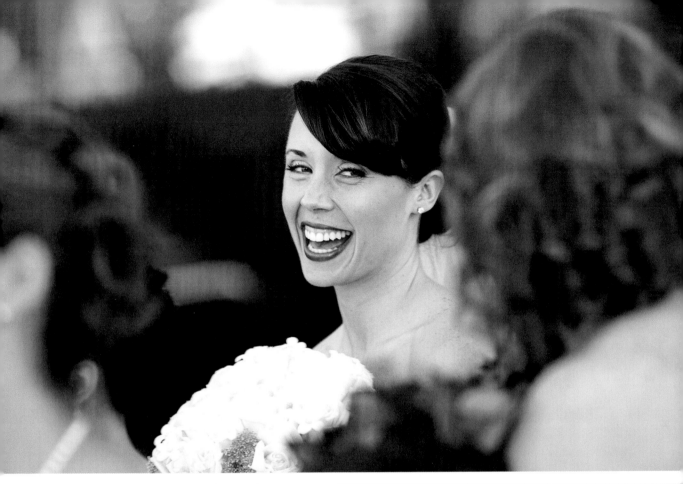

Equipment: Canon EOS-1D Mark III with EF 70–200mm f/2.8L USM lens. Exposure: f/4 at $^1/_{80}$ second and ISO 200. Focal length: 200mm.

to retrain ourselves to instantly capture fleeting, instantaneous moments as they occur. Then, in postproduction, we must learn to apply any enhancements needed to make the images stand out. By learning to capture a good quantity of quality images and style them in a unique and personalized manner, we can document beautiful and elusive moments for our clients and raise our profit margin as we do it. This is a personal challenge that never ends.

A wedding day is filled with important interactions, expressions, and emotions. Capturing the moments that matter and producing saleable, heirloom-quality images is a skill that

Intuition

Once you hone your skills, intuition will lead you through these types of shots. It will tell you where to be and when to press the shutter button in order to capture those emotions that will delight your clients. Finding just the right moment of expression is what gives your images impact.

makes you more of a commodity. If you are consistent in providing a personalized and high-quality product, your pricing can reflect that. These skills are best accomplished when you pair intuition with preparation and experience. You will learn what equipment might assist you, where to stand, and precisely when to push the shutter button. This comes from practice.

The Basic Approach

Working Unobserved

Candid photography is highly personal, in that you must release all of your control over the situation. The portraits you capture are instantaneous and emotionally charged, so you must never force or disrupt them. To document them honestly, you must work unobtrusively. Only when the subject is oblivious to your presence will you achieve genuine, natural expression. Push yourself to practice a total lack of interference while still creating a refined and creative composition. Avoid having anyone change their actions on your request. You want the portraits to be natural and documentary.

Equipment

It is human nature to play to the camera, so keeping your distance will help you avoid influencing your subjects. Try using a long zoom lens in order to shoot from the sidelines.

Simplify!

When shooting unposed images, you must try to get the simplest shots you can in a visually cluttered setting. Try to shoot from an angle that diminishes distracting elements, crop tightly, and wait for the subject's emotions to flow.

Below—Equipment: Canon EOS-1D Mark III with EF 85mm f/1.8L USM lens. Exposure: f/2 at $^1/_{200}$ second and ISO 1600. **Facing page**—Equipment: Canon EOS-1D Mark III with EF 24–70mm f/2.8L USM lens. Exposure: f/2.8 at $^1/_{320}$ second and ISO 100. Focal length: 25mm.

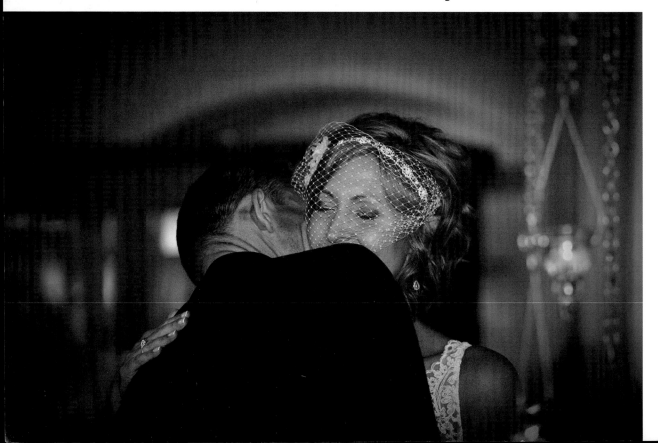

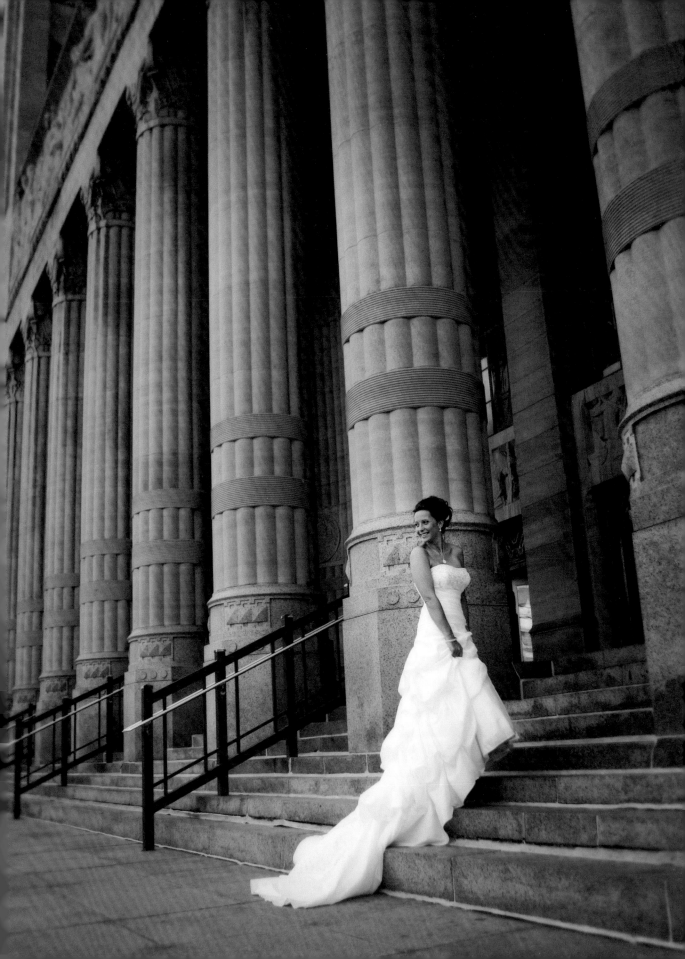

3 | Two Photographers

With two photographers, one person can get the conventional photos taken care of while the other captures moments of emotional elegance.

The First Shooter

The first shooter is the traditional photographer. This individual is in charge of a long list of must-have photographs that are customarily captured during a wedding. This task alone would create a full agenda for one person on one day, but this photographer must also be entertaining and likeable to everyone who attends the wedding. Their personality must come through in a pleasant and polite manner. They'll be "putting on the show" for the clients—cracking jokes, directing people, lending assistance, and giving helpful hints. They'll need to grab everyone's attention.

The Second Shooter

The photographer who is asking a group to pose and smile one moment cannot ask the subjects to stop looking at the camera and behave naturally the next. It's impossible to get unposed shots when you are in the spotlight. Therefore, there should be a second photographer who is free to explore the day as it presents itself. Having no list of required photos to take, he or she can move around, seek out perfect moments, watch scenarios unfold as a guest might see them, and capture them in as emotionally resonant a way as possible. This division of labor allows the second shooter to find the best lighting and positioning, then patiently wait to capture high-impact images.

The client should have no expectation as to the number of photos the second photographer will provide. If they return with only five photographs—but those five images are absolutely stunning—then they've accomplished their task.

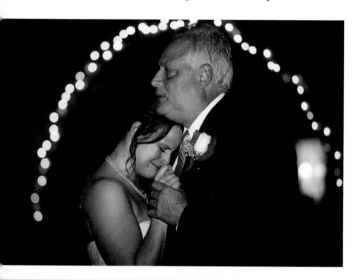

Shooting Solo

If you're shooting solo, you must make it clear to the bride that in order to capture unscripted moments as the day unfolds, you'll need to blend into the crowd, and she won't receive traditional wedding coverage. If that's just what she's looking for—and she understands the constraints and advantages of your style—she'll be happy with the final images.

It's important not to bite off more than you can chew. If you're capturing candid images, don't try to capture traditional photos too.

Left—Equipment: Canon EOS-1D Mark III with EF 85mm f/1.8L USM lens. Exposure: f/2 at $\frac{1}{60}$ second and ISO 1000. **Facing page**—Equipment: Canon EOS-1D Mark III with EF 50mm f/2.8L USM lens. Exposure: f/2.2 at $\frac{1}{50}$ second and ISO 640.

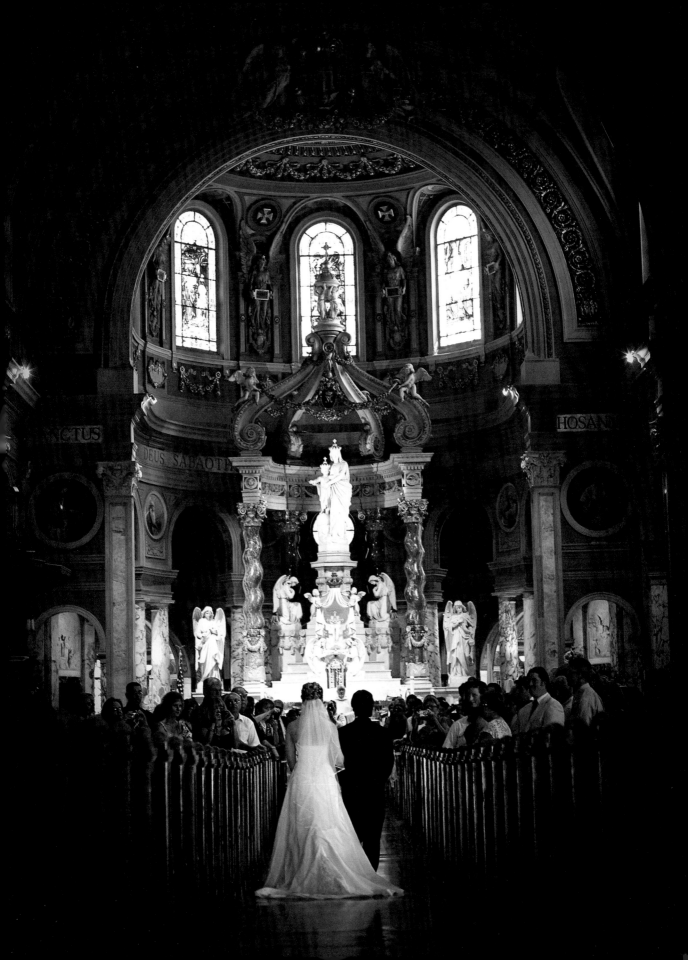

Preparing Clients

The Educated Client

Clients must understand that when you're shooting natural, unscripted moments, you can't guarantee that you'll capture specific shots. You'll need to explain that capturing candid shots demands your lack of involvement. The bride should know that she must be able to relax and enjoy the day and live in the moment so that you can do your best work. Assure her that when she sees her photos, she will be in awe.

You want your customers to be passionate about the product. If the bride can't identify the difference between a posed photograph and a documentary one, she won't fully appreciate your work. By educating your clients about the personalized nature of your approach, you can pique their interest, increase their excitement, set the stage for bigger sales, and anticipate great word-of-mouth advertising.

Cultivating Trust

Total trust is key to ensuring the best photos are captured. When clients aren't worrying whether or not they look good from a certain angle or wondering if you'll even get the shot, they will let down their guard.

If your client knows what you need from them and trusts you implicitly, they will be more

Equipment: Canon EOS-1D Mark III with EF 100mm f/2.8L Macro IS USM lens. Exposure: f/2.8 at $^1/_{200}$ second and ISO 800.

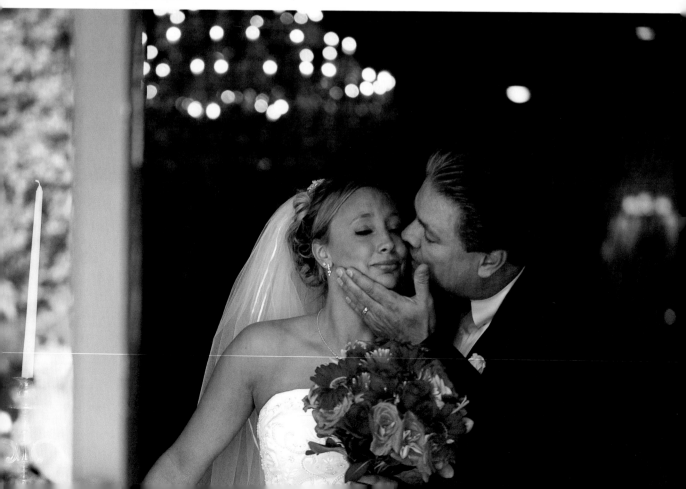

Top—Equipment: Canon EOS-1D Mark III with EF 100mm f/2.8L Macro IS USM lens. Exposure: f/2.8 at $^1/_{60}$ second and ISO 800. **Center**—Equipment: Canon EOS-1D Mark III with EF 50mm f/1.4L IS USM lens. Exposure: f/2.8 at $^1/_{125}$ second and ISO 125. **Bottom**—Equipment: Canon EOS-5D Mark III with EF 100mm f/2.8L Macro IS USM lens. Exposure: f/2.8 at $^1/_{100}$ second and ISO 320.

comfortable being themselves. Fostering this confidence is a process that starts before the wedding. Spend some time with your clients. Explain how you work. Answer their questions and ask some of your own. The better you know someone, the more likely you will be able to create photos that show their personality.

The better you know someone, the more likely you will be to create photos that show their personality.

Show Your Work

Be prepared to share sample images that are current and carefully presented. No one wants to see dated or damaged work. Present finished, framed pieces in addition to albums. The more examples you have at your fingertips, the more easily the points you are making will be understood. Showing a wide variety of images will also demonstrate to the bride and groom that you can handle whatever comes your way.

If the couple connects with your work and personality, they will develop trust in you and your talent and will be able to put you out of their minds on the big day, thereby allowing you to capture stunning, authentic moments.

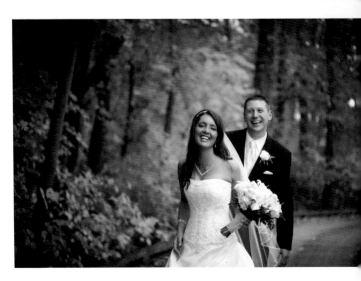

5 | Equipment vs. Artistry

Equipment doesn't make the moment. You do. It's your eye and your inner artist that's going to make it happen—regardless of all the techno-jargon we so love to indulge in.

We photographers are a rare breed. We love our gear almost as much as our children—and we really get excited about minute, cutting-edge changes. We are equipment junkies with few rivals. For a second, though, let's abandon all of our personal photographic idiosyncrasies. Forget about all of the fabulous things your new camera body can do. Nothing is as important as your thought process. You are a capable photographer who can quickly choose the right settings without difficulty. It's time to push beyond the basic mechanics of this craft. It's time to change the way you see.

It's time to push beyond the basic mechanics of this craft. It's time to change the way you see.

Think back to your first camera body, to the first pictures you ever shot. Remember that beat-up old friend you slung over your shoulder? It didn't matter that it didn't cost thousands of dollars or that it wasn't the newest or best model available. When you first felt the rush of pressing the shutter button at precisely the right moment, did it really matter what lens you used? All that mattered was the fact that you could record the moments you saw in your mind and make a beautiful piece of art. As we go forward, keep that mental image with you. Keep that feeling of awe and innocence in the back of your mind because we will be using that to reinvent our current attitude toward photography. All we care about is the image.

I'm not saying that your exposure and correct camera settings don't have an impact. Of course they do. But, the truth is, a good photograph is a good photograph regardless of what equipment or settings were used. When someone views the final image, they don't know

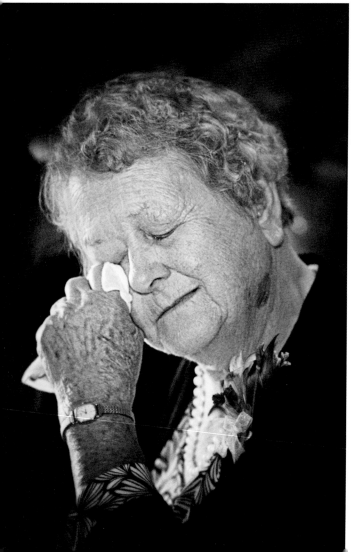

Equipment: Canon EOS-1D Mark III with EF 85mm f/1.8L IS USM lens. Exposure: f/2.2 at $^{1}/_{60}$ second and ISO 800.

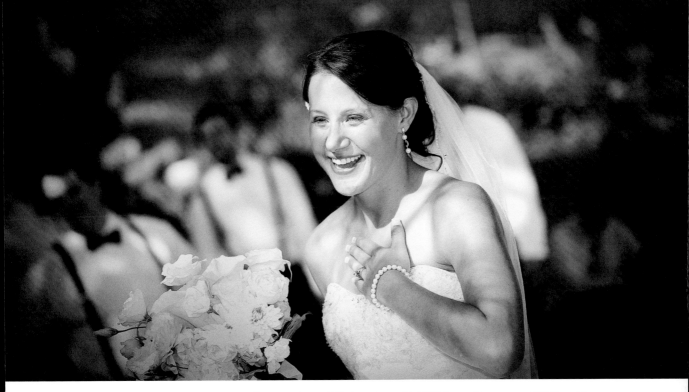

Equipment: Canon EOS-1D Mark III with EF 100mm f/2.8L Macro IS USM lens. Exposure: f/2.8 at $^{1}/_{300}$ second and ISO 100.

what means you used to achieve it. The camera is merely a tool; it is the viewer's response to your final image that is key. So, have confidence that you will get the technical aspects of your images right and give more thought to the creative aspects of what and how you're shooting. Think artistry, not mechanics.

The most advantageous thing you can do as a photographer is to understand the difference between your equipment and your artistry. To do this job successfully, you need a strongly developed inner eye and the patience to keep trying—and keep moving—until you get the exact moment that best tells the story. It is important to think of yourself as an artist, a painter of real-life happenings.

You're an Artist

Painters see their brushes and canvases as tools used to reflect their creative vision. Photographers, on the other hand, tend to believe the camera is doing the work and that we are simply watching and documenting scenes as they unfold before us. Just because our art is based on reality does not mean that the photos we take shouldn't have all the creative and emotional resonance of a painting. Your work will hang in your client's home for decades, and they should have the same affection for it that they would for a painting that speaks to them.

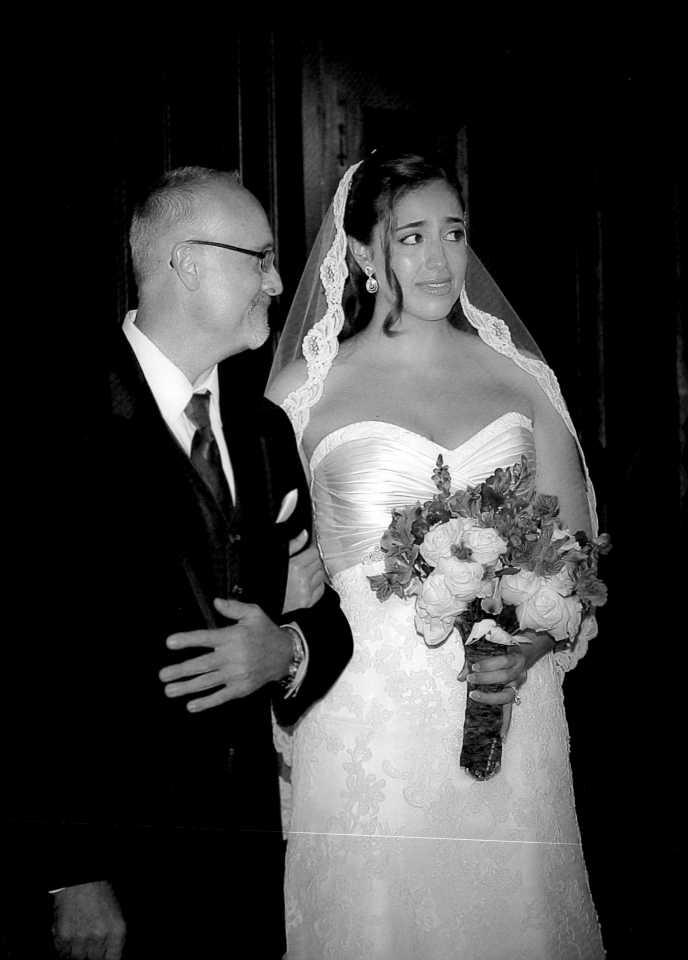

Allow the shots you take throughout the day to be governed by how you perceive the events around you—not by a preconceived checklist. Giving thought to the personal outlooks of all of the key players in a wedding will greatly enhance your ability to understand when critical moments will occur and why they happen.

Consider how the bride and groom are feeling. The bride is usually the embodiment of anxiety on her wedding day. She has spent countless hours worrying over details and preparing for one of the biggest days of her life. The groom is just as nervous and excited, and he wants to fulfill his bride's hopes and dreams. If you know what an event truly means to a client and what selective parts of it have special meaning, then you will be better equipped to provide the couple with the pictures that they are hoping for. The most dramatic picture opportunities present themselves during the most sentimental moments.

Taking time to consider these emotions in advance will greatly enhance your ability to anticipate and capture images that speak to the couple and to anyone who views your final product. Your training will help you know where to stand and when to use which piece of equipment, but your reaction time to instantaneous emotional displays can only be cultivated by adopting a fresh and adaptive mind-set to the events unfolding around you.

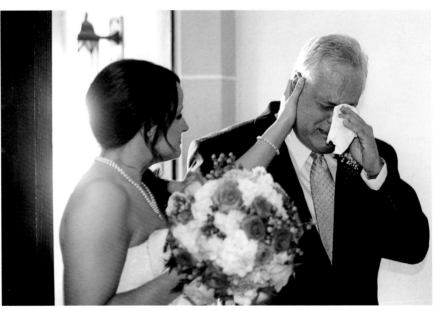

Facing page—Equipment: Canon EOS-1D Mark III with EF 50mm f/1.4L IS USM lens. Exposure: f/2.2 at ¹/₆₀ second and ISO 800. Right—Equipment: Canon EOS-1D Mark III with EF 50mm f/1.4L IS USM lens. Exposure: f/2 at ¹/₅₀ second and ISO 800.

Walk in Their Shoes

To successfully sell your images, you'll need to tune in to the bride's perceptions and feelings as you shoot. She ought to have a positive reaction to your images because they evoke once again the emotions she was feeling while you captured the shots, and she is able to relive the day through your work.

Flattering Portraiture

Perfect Moments

There are few days in a person's life as emotionally charged as their wedding day. Each moment is unique and passes by in a blur. It is your job to zero in on the expressions, angles, and lighting that best suits your creative vision, while trying your best to remove extraneous details from the shot and create a beautiful portrait. It can be hard to work with some of the locations you're given. Particularly busy and distracting items in your background or people walking into your shot can be problematic if you don't try to eliminate them as you go. You can't interrupt the action, so try changing angles, lenses, or changing your location altogether.

"Almost" Moments

When creating a candid portrait, it is your job to be discerning and selective about which moment to select. You will shoot rapidly and capture a multitude of "almost" shots, where everything is coming together but the subject's expression is just not quite right. Sometimes, at the height of laughter, a person's mouth can be open too wide, and they may appear to be baring their teeth to the camera like they want to eat it. Other times, they're just plain laughing too hard and it begins to come across as painful. Alternately, crying portraits can be problematic if the tissue gets in the way or it looks like the subject has a cold. They ought to look misty-eyed with joy, not sad or in despair.

The way people move and the reactions they will have to any one situation will vary infinitely. You must be ready to capture whatever is happening because you can't predict how they will look, and then edit carefully after the event in order to select the most flattering image. Always remember that you are creating candid portraiture—a natural and beautiful image that highlights the subject's emotion in the best-possible way.

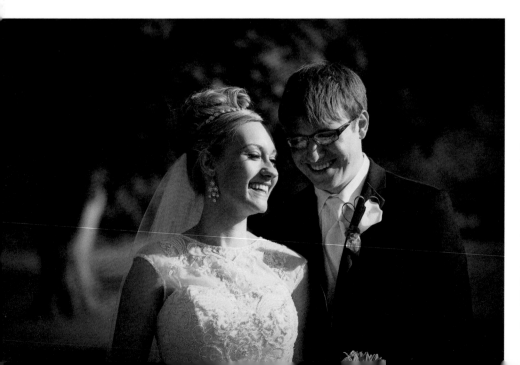

Facing page—Equipment: Canon EOS-1D Mark III with EF 70–200mm f/2.8L IS USM lens. Exposure: f/2.8 at $1/200$ second and ISO 100. Focal length: 150mm. **Left**—Equipment: Canon EOS-1D Mark III with EF 100mm f/2.8L Macro IS USM lens. Exposure: f/2.8 at $1/6400$ second and ISO 640.

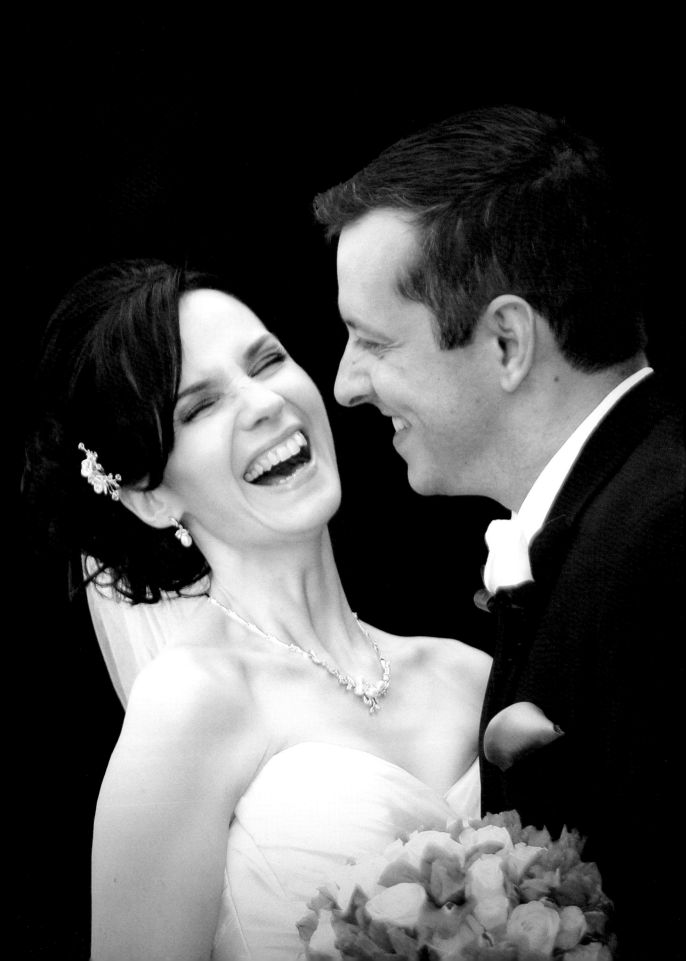

8 | Self-Growth

In order to push yourself to create a more beautiful and desirable product, set yourself some higher goals for things you want to work toward achieving. With this style of wedding photography, you will want to aspire to produce more profound images with visual impact, and learn to tell their story in new, creative, unexpected ways. Creating a streamlined editorial workflow to help you achieve your perfect product is a critical last goal.

Review Your Past Work

Begin by reviewing your photographic history. Examine both how far you have matured as an artist and what you would still like to achieve. What things would you have done differently or better during past shoots? If you are working on your editing skills, revisit some of your favorite past images and play with them until you create a fresh look. Try to move beyond simple technical criticism and examine the moment that you captured. It may have been the right moment, but were you portraying it in a thoughtful and artistic manner? Was your lighting and choice of angles well suited to your subject? Could your equipment have limited your ability to capture the scene in the way it played out in your mind? If you made a misstep, what could you have done differently?

High-Quality Materials

The ways in which you choose to provide your work to your client will directly impact your future referrals and subsequent sales. Give great consideration to the materials you select. We'll take a closer look at this topic later in the book.

Refine Your Image Presentation

Next, review your image presentation. Be sure you are comfortable with what you provide and that the customer is receiving it well. You might feel better providing proofs and prints of your work, or you may have already adapted to the digital-image-only package. Think about ways you could improve on either method. For example, if you choose to provide the client with their full-resolution images, are they all fully edited and ready to print? Have you provided them with an image count that doesn't overwhelm them but still maintains a full and accurate documentation of their wedding? In what kind of packaging will you deliver the images?

For those that provide framing options: Are they unique and different enough to distance yourself from big-name store brands? Might your imagery work better as a series, matted together in a diptych or triptych, in order to show the progression of events? Perhaps a high-quality canvas is in order for a single high-impact image.

These types of questions will help you refine your final product and decide what and how you should present it to your customers. It is something that you should revisit from time to time in order to make sure you are evolving alongside current trends. If you choose to avoid a trend (like digital copyrights, for example), incorporate your reasoning and the positive attributes into your sales pitch in order to keep your product viable.

Facing page—Equipment: Canon EOS-1D Mark III with EF 100mm f/2.8L Macro IS USM lens. Exposure: f/2.8 at $^1/_{200}$ second and ISO 320.

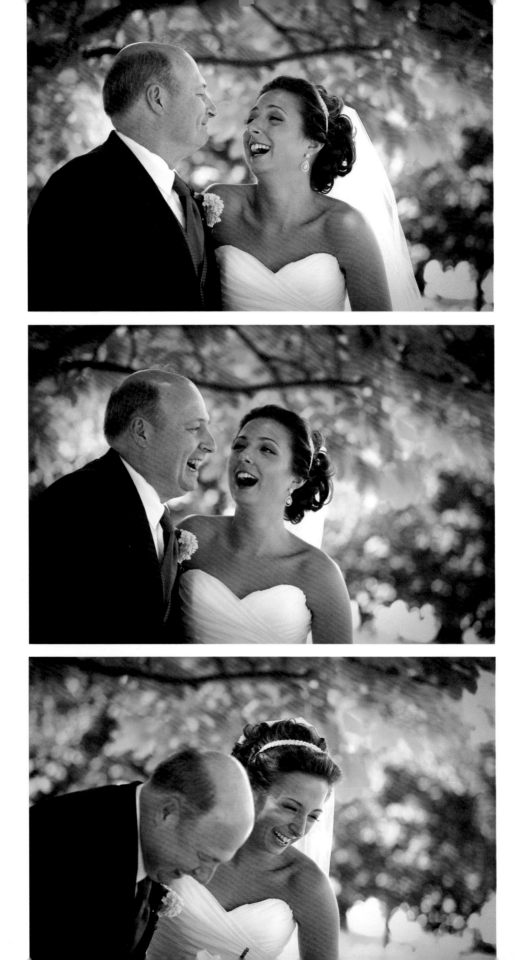

9 | Staying Ahead of Your Competition

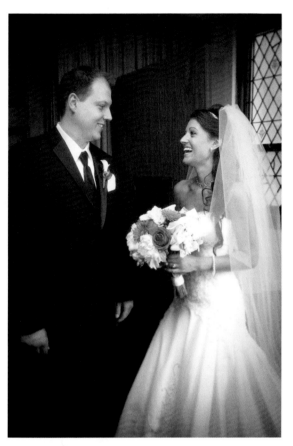

Equipment: Canon EOS-1D Mark III with EF 24–70mm f/2.8L IS USM lens. Exposure: f/5.6 at $^1/_{125}$ second and ISO 1600. Focal length: 24mm.

With the explosion of consumer digital photography, photographers must make sure that their product is more professional than ever. The quality of consumer-grade cameras is ever increasing, and the cost to own such a camera is low. Consumer images are getting better, so the perceived gap between their own and a professional photographer's is diminishing rapidly. It's easier for prospective clients to believe that anyone could shoot their wedding. A friend or an uncle could use a nice camera and "just do it themselves."

It is imperative to create as great a distinction as possible between amateur shots and your own work. We must be more precise than ever in our image capture and use high-quality materials to keep demand high. If you only offer low-quality materials or an overload of untouched, sub-par images, you risk becoming quickly obsolete.

> Edit to the best of your ability. Delete repetitive and unflattering images or photos with serious technical problems.

Always edit to the best of your ability. Delete all repetitive and unflattering images or photos with serious technical problems. Once you have a set of very good images, go through them with a fine-tooth comb to make sure everything is straight, color-corrected, and retouched if necessary. Try to correct any errors or extraneous details using cropping after the fact. There must be nothing sloppy. It's important that your products look highly finished.

If you are a photographer who likes to explore graphic art and unusual filtering of your images, add whatever artistic finishing touches each image needs. Avoid putting it off and saying, "I'll do it later," or "I'll do it if they order that" because the client may avoid ordering it altogether. They can't be expected to understand your vision of what a photograph *could* be.

Alternately, if the image is a portrait, they may be highly unsatisfied if their blemishes and flaws are on display. You risk creating an unhappy client right from the start if these things aren't done before they receive your work. Clients demand polished work from a professional photographer.

Developing a new style is all about embracing change. Adopt an avant-garde approach and nix the "oh, I've seen that before" attitude that many photographers develop after seeing dozens or hundreds of weddings. Shoot for impact and cultivate your own style, while avoiding any laziness on the editing and presentation end in order to stay ahead.

Equipment: Canon EOS-1D Mark III with EF 100mm Macro f/2.8 IS USM lens. Exposure: f/2.8 at $\frac{1}{400}$ second and ISO 250.

Self-Growth Keeps You Viable

Pushing yourself to continually achieve new imagery keeps you ahead of the amateur photographer trend. Consumer cameras are so high-grade now that some potential customers will feel that they can simply do it with their own camera, and that your skill isn't worth what it once was. It is your photographic sensibility that must stay sharp, because that is always worth more than equipment! Staying current on both photographic trends and the newest presentation materials available will help keep your business immune to the competition of "we can do it ourselves," or "we can have a friend do it."

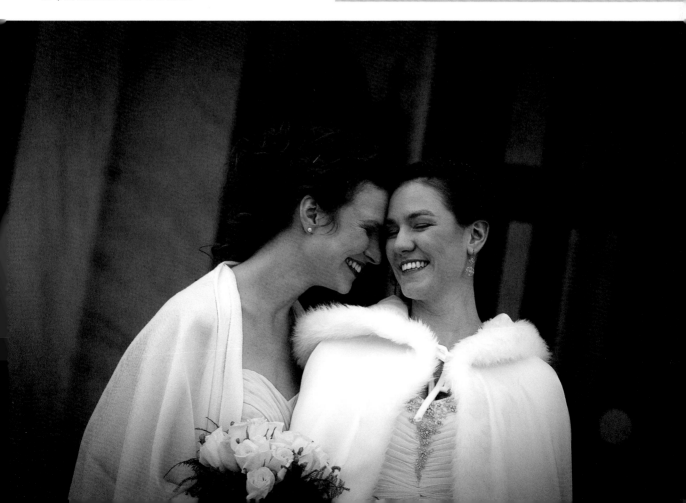

| # The Decisive Moment

The decisive moment is the instant of peak action or emotion. Images that capture the decisive moment have a unique ability to affect the audience and tell a story.

The decisive moment occurs in a split second, but a rich complexity arises from the interplay of the subject's emotion in that instant and how that feeling is interwoven into their life.

When we attempt to isolate a moment that shows an individual's personality and emotions, our success is contingent on the precision of our selection. The decision about when to push the shutter button must be made with intelligence, understanding, and careful thought.

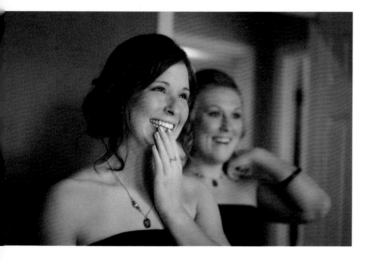

Left—Equipment: Canon EOS-1D Mark III with EF 50mm f/1.4L IS USM lens. Exposure: f/2 at $^{1}/_{400}$ second and ISO 1000. **Facing page**—Equipment: Canon EOS-1D Mark III with EF 70–200mm f/2.8L IS USM lens. Exposure: f/6.3 at $^{1}/_{800}$ second and ISO 200.

Henri Cartier-Bresson

Famed photographer Henri Cartier-Bresson spent his life seeking decisive moments. In *Henri Cartier-Bresson: Photographer* (Little, Brown and Company, 1979), Cartier-Bresson wrote:

"Manufactured" or staged photography does not concern me. And if I make a judgment, it can only be on a psychological or sociological level. There are those who take photographs arranged beforehand and those who go out to discover the image and seize it. For me, the camera is a sketch book, an instrument of intuition and spontaneity, the master of the instant which—in visual terms—questions and decides simultaneously. In order to give meaning to the world, one has to feel one-self involved in what he frames through the viewfinder. This attitude requires concentration, a discipline of the mind, sensitivity, and a sense of geometry. It is by great economy of means that one arrives at simplicity of expression. One must always take photos with the greatest respect for the subject and for oneself.

To take photographs is to hold one's breath when all faculties converge in the face of fleeing reality. It is at that moment that mastering an image becomes a great physical and intellectual joy.

Cartier-Bresson describes exactly the thing we are seeking, the type of photography that literally

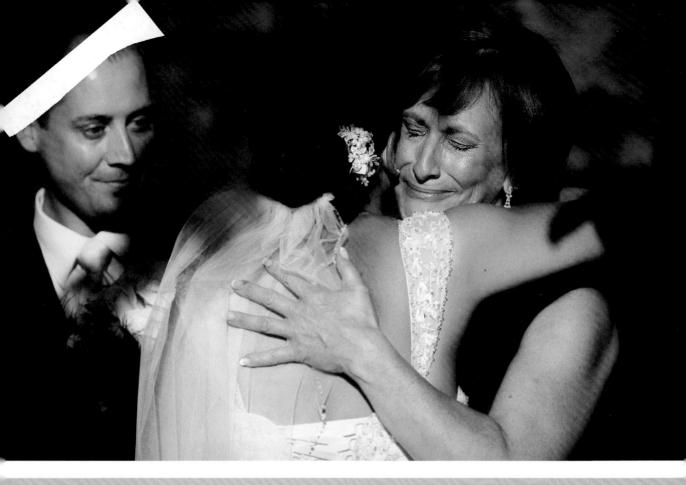

reveals personality. The resulting image releases information about the subject in psychological terms. We are documenting a moment and examining the complexity of human emotions. We are also portraying raw emotion, the essence of the human experience.

In the book's introduction, Yves Bonnefoy writes:

Technique is, for Cartier-Bresson, only a means, which he refuses to aggrandize at the expense of initial experience, in which the meaning and the quality of the work are immediately determined. Of what use are shutters of different speeds, papers of different sensitivities? They attain levels of perceptible reality—for example . . . a fleeting gesture or expression, or the lovely texture of skin or fabric—that could not be detected without their assistance.

Bonnefoy highlights an important point: it doesn't matter what technical means you have at your disposal, as long as they are sufficient to capture a quality image. What is truly important is your instinctive understanding of the "levels of perceptible reality" we are seeking.

To shoot in this style you must be sharp, intelligent, and—most of all—fast. In the same book, Bonnefoy states that success relies on whether or not "[. . .] he who holds the camera can move into action almost as fast as the shutter, can surrender to intuition, can pounce like a wild, stalking animal on what moves with lightning speed." The metaphor is a valuable one. Think of instinctive capture as a hunt. You are the hunter seeking your prey, but you are thoughtful and selective about what subject you choose to shoot. If you seek out your subject with that kind of dedication, you will capture the hyper-reality we are interested in, with great results.

11 | Work Fast, Shoot Smart

The decisive moment will pretty much always happen shockingly fast. The peak action will take place so quickly that you almost miss it. To make matters worse, if the subjects are unaware of the photographer's presence (which encourages the types of spontaneous interactions you want to capture), there's a good chance they will be moving around a lot, obscuring your view and making it harder to get the shot. Of course, action and emotions will often unfold next to you or behind you, so you'll have to be ready to move at any time. To capture the decisive moment from a flattering angle in a split second, you'll have to be ready and on point.

Traditional wedding photographers are dedicated posers of individuals and groups, allowing time to pose and re-pose whenever necessary. They don't work slowly, but they don't need to be ready in a split second, either. Those of us who make it our job to capture spontaneously need a fast reaction time. The tempo at which we must move into position and respond by pressing the shutter button must be lightning-fast. If you can see a moment happening but can't get your camera up and focused immediately, you will miss it. If you shoot from the wrong angle because you were off by two steps, you won't get a stand-out shot. You need to be

Equipment: Canon EOS-1D Mark III with EF 85mm f/1.8L IS USM lens. Exposure: f/2.0 at $^{1}/_{250}$ second and ISO 800.

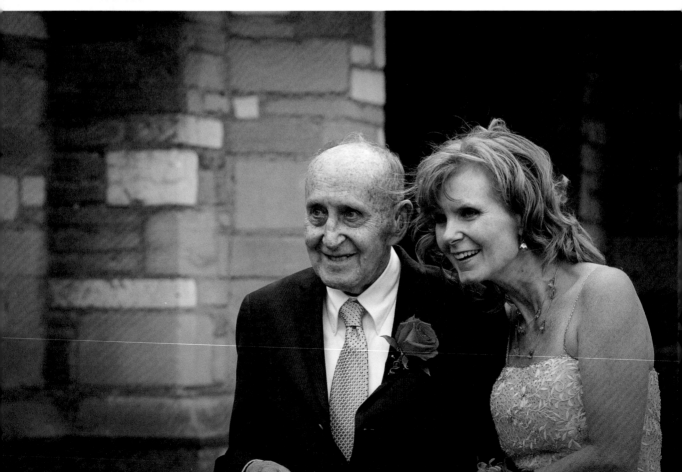

mobile at all times and never lazy about moving your feet quickly to get into place. Focusing and shooting in a split second must become second nature.

You need to work without hesitation, and that is a skill that can only be mastered with practice.

What can you do to practice? Before you ever get to a wedding, be sure you are a master of your equipment. There should be no lag time on your part. Something as simple as autofocus, which seems like a no-brainer in theory, can become a big problem when you're in changing lighting conditions with groups of moving subjects all around you. You need to work without hesitation, and that is a skill that can only be mastered with practice.

When I was teaching myself, I found that some of the best practice subjects were animals, followed closely by children. They both move fast and don't care about what you're doing, so you get lots of chances to practice your technique. Simply follow them around and try to get great shots. It's hard at first, but you'll get the hang of it. Darker subjects, like black cats or dogs, are often harder to focus on—especially in low-light situations—so they present a greater shooting challenge. If you don't have a pet or a child, visit a friend who has a pet or offer to babysit for a few hours now and then, or offer free photo shoots to build your skill set.

Photographing animals or children will also force you to be on your feet, moving quickly to get in front of them. In an outdoor setting, you'll find that you move a lot farther and a lot

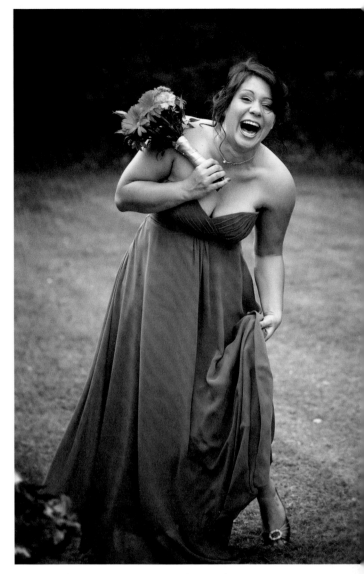

Equipment: Canon EOS-5D Mark III with EF 70–200mm f/1.8L IS USM lens. Exposure: f/2.8 at $^1/_{500}$ second and ISO 250.

faster. This kind of practice will make it more natural for you to move and shoot with little or no setup. Just moving around with a lot of equipment can be hard at first, but the more you do it, the easier it will be. You really can't be too fast, so practice often.

| # Your Best Shot

How do you select one moment over another—especially when they are similar? Whether it's in-camera or during the editing process, you will constantly be grappling with this question. You need to be able to discern which shot is strongest, most flattering, and has the most storytelling ability. It has to have a wide appeal to the bride and her audience of friends and family, but it also needs to be creative and unusual enough to make people stop and take notice.

When people are moving and interacting, emotional displays will inevitably happen.

Left and facing page—Equipment: Canon EOS-1D Mark III with EF 100mm f/2.8L Macro IS USM lens. Exposure: f/2.8 at $^1/_{2000}$ second and ISO 250.

Unfortunately, the way that people move is sometimes far from flattering. A prime concern is when a subject pulls their chin toward their chest. This often happens during laughter and it creates a double chin. I find that when the subject is talking to someone tall or laughs so hard they throw their head back a little, I can avoid these unflattering angles.

You need to be able to discern which shot is strongest, most flattering, and has the most storytelling ability.

Because the natural moments we want to capture are fleeting, you will—especially in the early stages of your endeavors—end up with a percentage of images that just don't work as well as others. For example, imagine you have a series of images of someone telling a joke. During the funniest part of the joke, everyone will appear to be having fun and will look at ease. This might be the decisive moment, but the portrait may not be salable due to a bad angle or unflattering expression. Look at each image as a portrait, then pick the shot that is most flattering and best documents the moment.

Be Selective

In the studio, you would never shoot someone in an unflattering manner. Use the same criteria when capturing unposed shots.

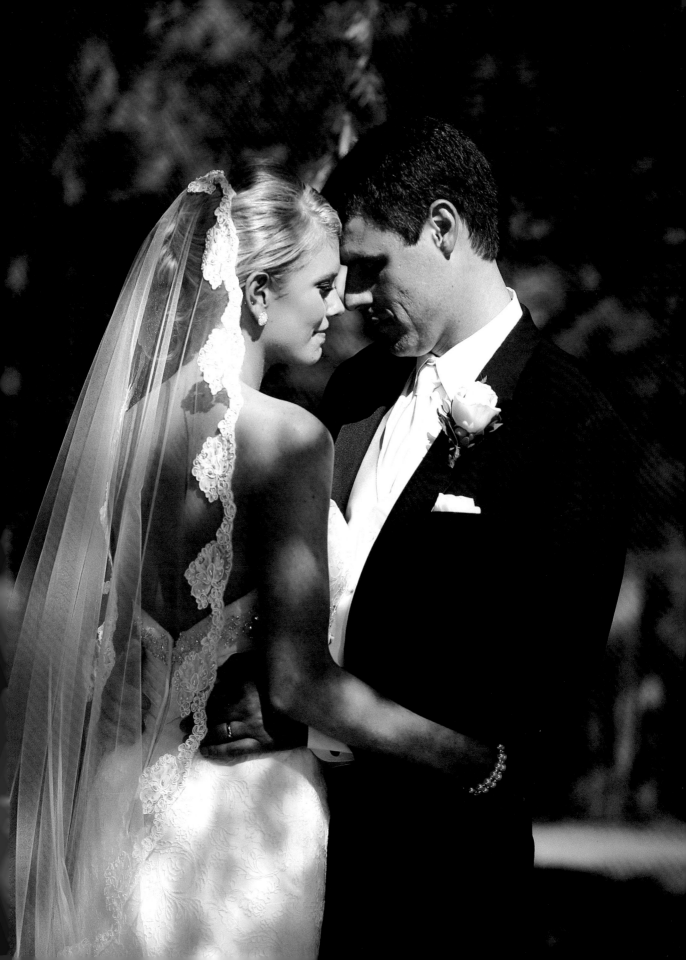

13 | Preparation

Equipment: Canon EOS-1D Mark III with EF 100mm f/2.8L Macro IS USM lens. Exposure: f/2.8 at $^1/_{160}$ second and ISO 250.

Training yourself to recognize and anticipate the decisive moment is the key factor in learning to shoot effective, artistic candid images. To really step up your game and sharpen your intuition to best capture people in their element, you must commit yourself to hunting these singular opportunities 100 percent of the time. When you go out on a shoot, you'll need to adopt a new attitude, coupled with some preparative thinking.

Have you ever turned around while at a shoot to find your subjects hugging, with their faces all scrunched up, just aching with happiness, and missed the shot? Maybe you saw the embrace and reached for your camera but, once you wrestled it from its case, you found its strap was knotted around your arm and the lens cap was on. By the time you were ready to compose the shot, the interaction was over and the subjects had moved on. Had your camera been ready to go, prefocused with the lens cap safely tucked away, you would have got the shot. Instead of kicking yourself, you'd be patting yourself on the back.

Avoiding this kind of mishap is simple: just be prepared. Professional athletes don't leave anything to chance. They do everything in their power to eat correctly, hydrate themselves, stretch, and warm up before the event. Photographers who want to take their artistry to the next level should adopt the same attitude.

For the best results, check your camera settings often. Maybe you changed your aperture during the vows and forgot to reset it when you went outdoors. Perhaps you turned your flash off for a long exposure earlier and are now preparing to shoot the first dance. You and I may scoff and call these rookie mistakes, but the truth is, something like this happens to all of us on occasion. Given that the odds are already against you, it's a shame to let a simple, preventable error ruin the shot of a lifetime. So check those settings. Stick your lens cap in your pocket. Put your strap around your neck. Be

sure everything is easily accessible and ready to shoot at all times.

If your subject is engaged in an action or conversation, zoom in and find your desired focal and cropping points.

Then, go a step farther and seek out your subject. Prefocus on them. If they haven't arrived yet, focus on a person or object in the general area where you're expecting them to be. This is especially important in a dark environment, as low light can cause autofocus lenses to operate slowly. Keep an eye on everyone around you while you're making your preparations. People will be getting used to you being there and may start to ignore your presence. You'll be able to snap off a few dramatic candids of the guests while you wait.

If your subject is engaged in an action or conversation, zoom in and find your desired focal and cropping points. The more accurately you can compose your image in the camera, the less you'll have to fix later. Once your background is perfect, your cropping is good, and everything is lined up just right, don't jump the gun. Keep your camera up and ready. When the decisive moment arises, you'll feel it in your gut. When the subject is mid-laugh or just starting to tear up, you'll be prepared to fire away. As photographers, we tend to look at the technical aspects: the shot looks right, it's in focus, and no one is in your way, so you shoot. But consider how different the shot could be if you just wait.

Equipment: Canon EOS-1D Mark III with EF 70–200mm f/2.8L IS USM lens. Exposure: f/3.2 at $^{1}/_{250}$ second and ISO 200. Focal length: 200mm.

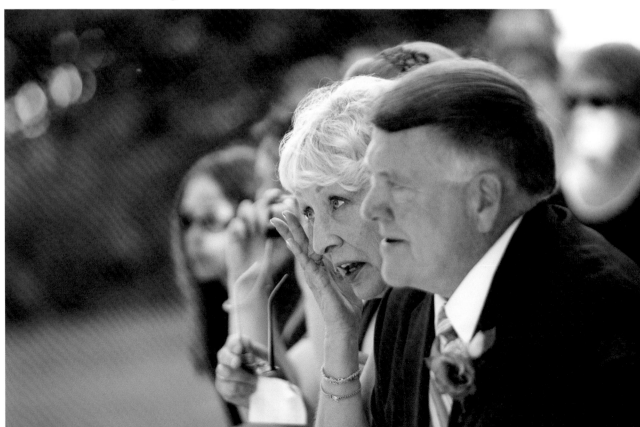

Crowds

Crowds are simultaneously the most frustrating and the absolute best place to shoot. The good news is that you can move through the room and shoot almost inconspicuously. People are engaged in conversation and will be oblivious to you. They are also moving and constantly interacting, which creates an array of moments for you to capture. By simultaneously distracting themselves and creating photo opportunities, they're doing half the job for you!

In a crowd at a wedding, expressive and sentimental moments are sure to occur. I often get bumped into, then hear the subject say, "Oh! I didn't see you there." That's exactly what I want. That shows me that I'm working unobtrusively, with no posing or participation by the subject. My presence is not changing their behavior.

The bad news? People walk into your shot. And you'll get stepped on. This makes it important to learn to navigate around people and keep one eye on who's coming toward you.

Equipment: Canon EOS-1D Mark III with EF 50mm f/1.4L IS USM lens. Exposure: f/2 at $^1/_{60}$ second and ISO 500.

Learning to Wait

Sometimes our subjects are extremely expressive. Right from the start, you know it's going to be a great wedding shoot. Other times our subjects are more reserved. When this is the case, I make it my business to stay near them throughout the day, waiting for them to open up. Often, I only get one or two chances at it—and they may not open up until the reception. That means I spend seven hours waiting and half a second capturing the fleeting laughter. That's just the way it works. But it makes it more gratifying when I finally get the shot. When the family sees the image, they'll often tell me something like "I can't believe you got my dad smiling. He never smiles in pictures!"

Refrain from simply shooting to record who attended the event. Nothing is as boring as a portrait of someone with no expression whatsoever.

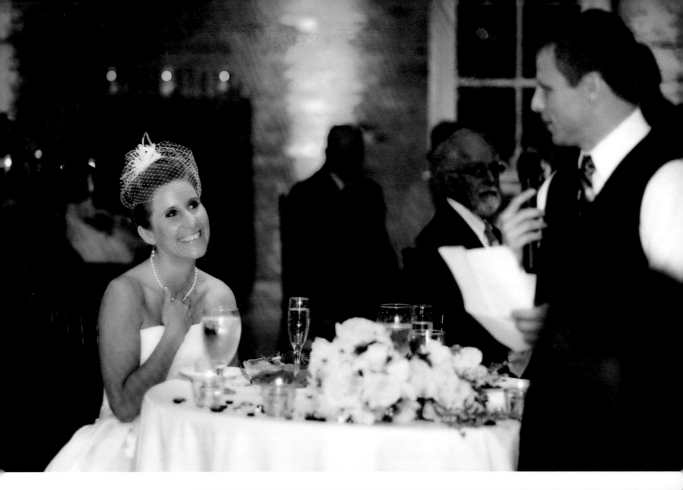

Above—Equipment: Canon EOS-1D Mark III with EF 85mm f/1.8L IS USM lens. Exposure: f/2 at $^1/_{60}$ second and ISO 1250. **Right**—Equipment: Canon EOS-1D Mark III with EF 85mm f/1.8L IS USM lens. Exposure: f/2.5 at $^1/_{60}$ second and ISO 1000.

The Receiving Line

Practice

A receiving line presents fantastic opportunities for capturing genuine interactions and authentic expressions. It's an excellent chance to practice your skills.

Receiving lines are chaotic; they are full of happy greetings and intense, often overlooked moments of joy and excitement. As the bride and groom greet each person, stay focused on their faces. Grab your favorite lens, focus in on them individually, and wait until that one person who will really excite them comes along in the line. For the sake of argument, let's say that person is the mother of the bride. Her arrival, especially directly following the ceremony, is likely to prompt a few tears. Mom will probably cry a bit, too, so keep your eyes peeled for her expression.

Watching and Waiting

Another skill you can practice while photographing the receiving line is working within a crowd. You'll need to be vigilant about watching the guests because they won't be mindful of you. If you see someone approaching, you'll have a better chance of reacting to them and shifting your position to salvage the shot.

The impact of the image depends on how much emotion we see in the subject.

All the while, remain ready. The bride could become emotional without warning. When she sees that old friend from high school, you want to be sure you've closed in on her face and are ready to go. On the other hand, be selective in the moment you choose. You are painting a portrait of her happiness that will last her lifetime and beyond, so find that perfect moment, not just the first one that comes along. The same goes for documenting more poignant moments. The impact of the image depends on how much emotion we see in the subject. Don't just create a portrait of someone crying; a more subtle, soul-searching expression can be far more compelling in its complexity and intrigue. Avoid clichés and look for loaded moments.

Left—Equipment: Canon EOS-1D Mark III with EF 85mm f/1.8L IS USM lens. Exposure: f/2.2 at $^1/_{320}$ second and ISO 250. **Facing page**—Equipment: Canon EOS-5D Mark III with EF 50mm f/1.4L IS USM lens. Exposure: f/2.0 at $^1/_{1000}$ second and ISO 2500.

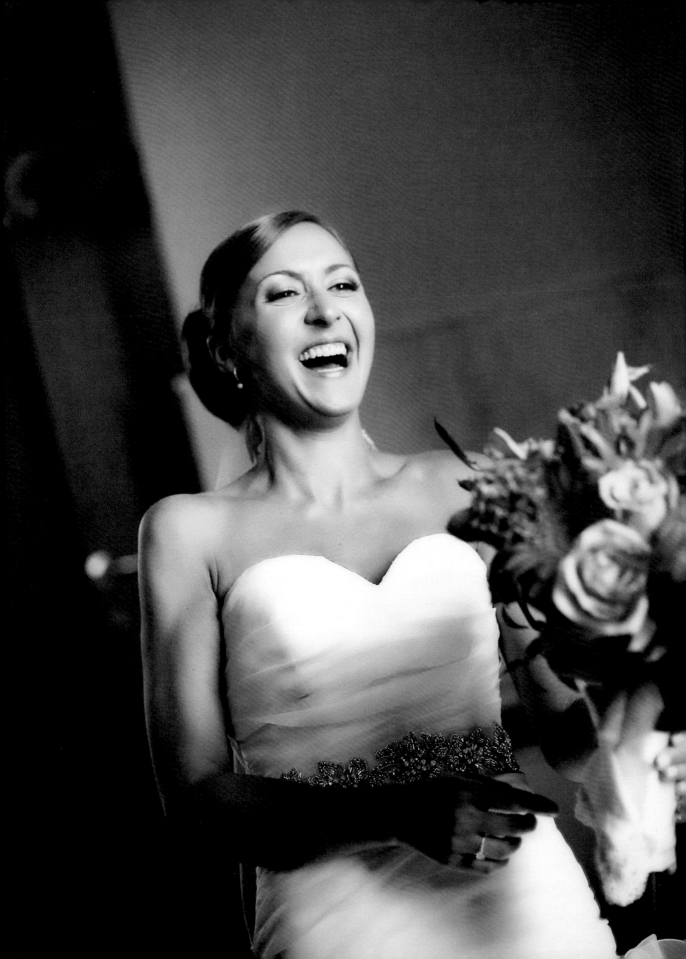

| # Environmental Portraiture

Zeroing In

It's possible to capture natural expressions and unscripted actions in such a way that the images almost look posed. To do so, you must identify moments so effortlessly that you have time to carefully compose, crop, and edit in-camera before the decisive moment has passed. For the best results, frame just one subject in your viewfinder when possible and limit your subjects to two or three when photographing a single person just isn't feasible. Achieving those goals will take tremendous patience, but it gets easier

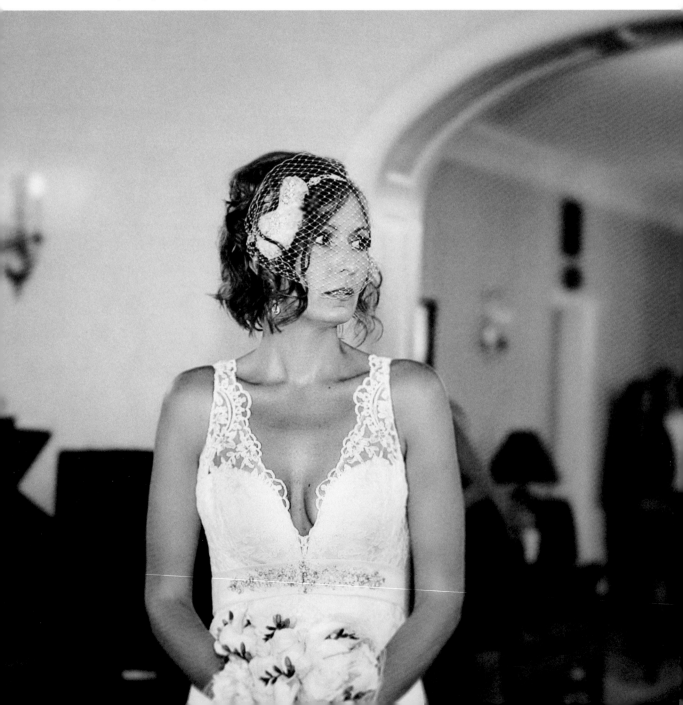

with experience. The better the image is when it's captured, the more of a "wow" factor your final portrait will have.

Keep your depth of field relatively shallow and try to rid the frame of any extraneous details. This can often be the toughest part, since you have no control over the action in front of you. If the bride is standing in front of a bookcase, you're stuck with it. Hopefully, the perfect moment won't occur until she's walked away from the bookcase, but you have to be prepared to deal with the unsightly background. Try a very shallow depth of field. Look for different angles. Keep your mind open to the possibilities and don't disregard any opportunity because of an undesirable background. A monotone treatment in postproduction can eliminate problematic bold colors in your background.

Keep your depth of field relatively shallow and try to rid the frame of any extraneous details.

Striking a Balance

When shooting a wedding, it is hard to know where the action will occur and who will be involved. It is even harder to predict if your subject will move out of the frame at a moment's notice. This can make it tempting to merely record the events in front of you—to abandon the rules of good composition in favor of getting something. Conversely, if you spend so much time thinking, reasoning, and worrying over whether or not *this* is the decisive moment, you can miss the entire interaction.

The truth is, things won't always happen perfectly. It won't be possible to take every picture with the attention it deserves. Don't despair, just keep shooting. If you have time to compose a flawless image, that's wonderful—but if you are simply too far away when the action is happening, shoot it anyway. Postproduction work can rectify many errors and salvage the shot. Thoughtful cropping will become one of your best tools.

Equipment: Canon EOS-1D Mark III with EF 50mm f/1.4L IS USM lens. Exposure: f/2 at $^1/_{60}$ second and ISO 1000.

Verbal Cues

Eavesdropping, though socially taboo, is usually a pretty good idea on the wedding day. People aren't going to stop their conversation to clue you in to what they're feeling and how they're about to respond, so pay attention. Listen to the conversations taking place around you—especially when humorous stories are being told, as these are likely to elicit great expressions. If you hear a key phrase like, "I haven't seen you in so long!" or "I can't tell you how proud of you I am," highly charged emotions will likely follow. If you hear the bride's mom tell her, "If your father were here, he would be so proud!" get ready to photograph the bride. She's likely to respond to that meaningful phrase with a hug or a few tears—and if the bride is tearing up, Mom won't be able to help herself. There's no downtime when you're photographing authentic interactions.

There are some often-uttered verbal cues to be on the lookout for. In polite Western society, for instance, when people see the bride, they are expected to say something like, "You look so beautiful!" The compliments a bride receives on her wedding day can be overwhelming and exciting. Be ready to capture how she reacts to them. Whenever you hear a complimentary phrase, get ready.

"I'm So Glad You Made It!"
Another important phrase often uttered on the wedding day is "I'm so glad you made it!" When the bride or groom speak these words, you can be pretty sure that the person they're speaking to is important to them and/or is an out-of-town guest whom they have not seen in a long time. Chances are that guest is someone whom you should keep an eye on throughout the day.

"That Means So Much to Me!"
"That means so much to me!" is a tip-off that a compliment has just been given. Everyone appreciates a flattering remark, so there will be some kind of positive reaction to this nicety. That means there will also be a great opportunity to document the reaction. Compliments that the bride receives on any aspect of the wedding will reinforce the idea that the day is a success. It is very important to the bride that the day goes well, so you will see relief and pleasure on her face following that sort of compliment. The phrase often prompts hugging—and where

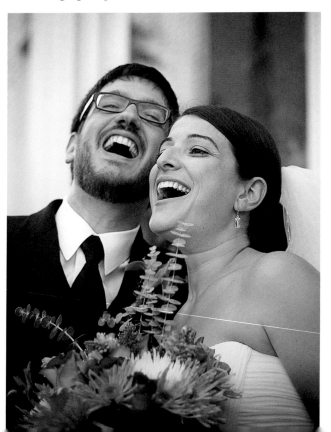

Equipment: Canon EOS-1D Mark III with EF 50mm f/1.4L IS USM lens. Exposure: f/2 at $^1/_{500}$ second and ISO 320.

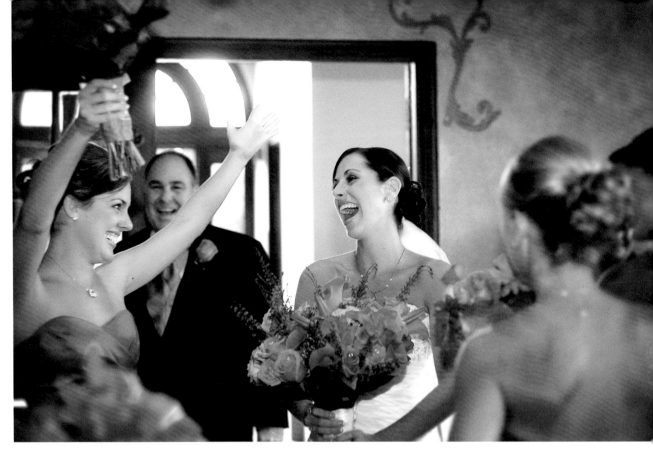

Equipment: Canon EOS-1D Mark III with EF 50mm f/1.4L IS USM lens. Exposure: f/2 at $^1/_{80}$ second and ISO 800.

there's action, there's the opportunity for additional emotional displays.

"Oh My God!"

You'll hear the words "Oh my God!" uttered for a variety of reasons. It may be a guest's or parent's reaction to how beautiful the bride looks. It could indicate nervousness and excitement. Often, the phrase precedes the kind of emotional reaction that causes other people to get involved. For example, during the morning preparations, let's say the bride is opening a gift that her husband-to-be has sent as a surprise and says in a low voice (or a high-pitched squeal), "Oh my God!" This suggests the bride is shocked and overwhelmed. Your first oppor-

tunity lies in photographing the bride's reaction, but you know that the bridesmaids are going to crowd around to get a look at the gift. Everyone will be laughing, smiling, and talking, which means you'll have an opportunity to capture lots of emotionally charged moments.

If you've followed the advice in section 13, you will have your camera ready to go. When you hear "Oh my God!" zoom in on the bride, then zoom out to include the two people nearest to her, and finally pull back to show the rest of the girls and see whose reaction stands out. Be aware of the entire group at all times. Seek out movements and emotional reactions. This provides your bride with three choices and adds variety to your work.

Body Language

In the midst of the chaos of the wedding day, whom do you focus in on? How do you know who is most likely to be excited next? Verbal cues are a great indication that something photo-worthy is about to occur, but it's not the only sign. Body language can also help you to anticipate important moments.

Photographs are a record of human body language. As we've discussed, the moments that we strive to document are the ones that tell a story without words. Reading body language is not an exact science (it is open to varying interpretations), but it is still relatively effective, especially during a documentary-style wedding shoot.

The body language that creates the most impact and communicates most effectively to the viewer is strong and clear. As you survey the scene, look for clearly distinguishable, recognizable, and familiar gestures. Watch body movements and key in to what people are doing. If you were watching TV with the sound off, the actors' movements and behaviors would still communicate a good portion of the story to

you. Many times, you'll find that you know just what they're feeling or thinking without overhearing the conversation.

Since body language is automatic and usually spontaneous, it is a tool that you, as an outsider, can sometimes rely on to reveal that a moment

Equipment: Canon EOS-5D Mark III with EF 70–200mm f/2.8L IS USM lens. Exposure: f/4.0 at $^{1}/_{200}$ second and ISO 250.

Emotions Are Contagious

Watch for clear displays of emotion. Even if you catch one out of the corner of your eye and are unprepared for it, remember that emotions are contagious. People tend to see what others around them are feeling and respond in kind. If a woman starts crying, it is likely that her sister or a friend standing next to her will too.

is about to happen. For example, if you see a woman searching through her purse for tissues during or just after the ceremony, it often means she's been moved to tears. If two people are moving toward one another, a hug is probably imminent, especially at a wedding. (Remember, emotions run high at a wedding; hugging and kissing are rather commonplace, so virtually any movement could lead to one.) If two people—like the bride and her father—are simply standing near one another, they are worth keeping an eye on. At some point, it is likely that one of the two of them will put their arm around the other or share a knowing glance.

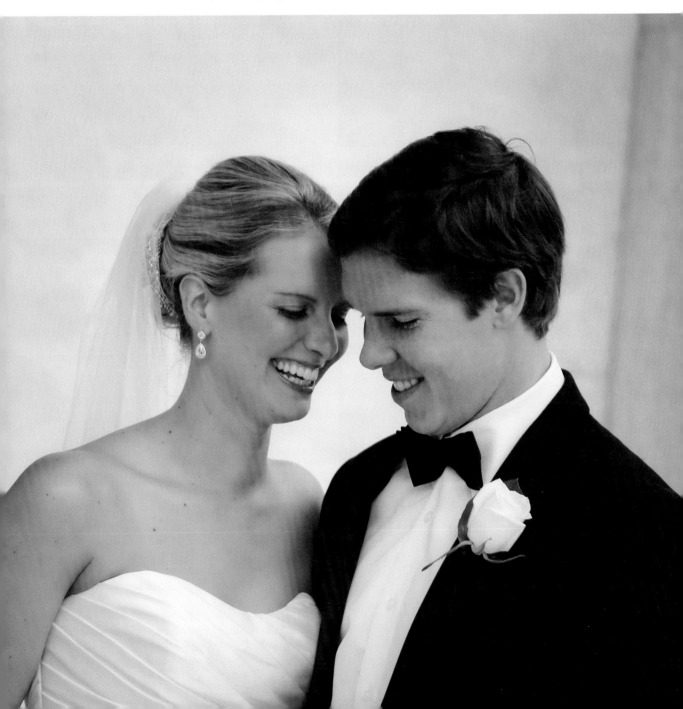

Traditional Moments

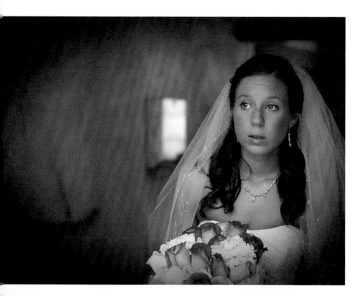

The wedding day is full of traditions—from the bride and groom not seeing one another until the ceremony begins to the exchange of vows to the exit. Come the reception, you'll typically find a receiving line, a first dance, a bouquet/garter toss, and cutting of the cake. Keeping these traditions in mind can help you determine where to position yourself for the best shots as the action naturally unfolds.

This combination of emotions peaks in those few minutes before they walk down the aisle . . .

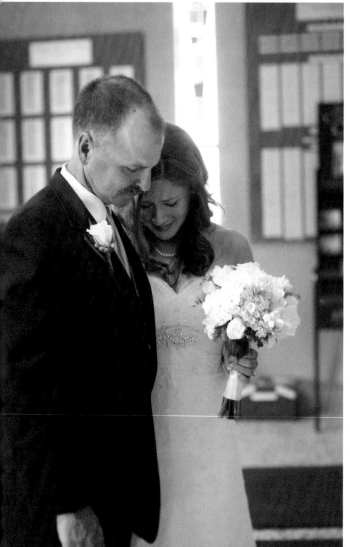

Consider the moments leading up to the procession. This is a time when most brides and their fathers are more emotional and demonstrative than usual. It is the pinnacle of their excitement and the climax of the wedding in many ways. Most people are rather nervous about public speaking in any capacity, and the bride is about to stand up in front of everyone she knows to recite her vows. It is daunting and exhilarating for the bride and bittersweet for her dad. This combination of emotions peaks in those few minutes before they walk down the aisle—meaning that you will likely be able to get some emotional shots. Not everyone reacts in the same way, so you must continue to be vigilant and look for unexpected opportunities.

Top—Equipment: Canon EOS-1D Mark III with EF 50mm f/1.4L IS USM lens. Exposure: f/2.0 at $^1/_{160}$ second and ISO 1000. **Bottom**—Equipment: Canon EOS-1D Mark III with EF 50mm f/1.4L IS USM lens. Exposure: f/2 at $^1/_{200}$ second and ISO 1250. **Facing page**—Equipment: Canon EOS-1D Mark III with EF 24–70mm f/2.8L IS USM lens. Exposure: f/5.6 at $^1/_{125}$ second and ISO 400. Focal length: 24mm.

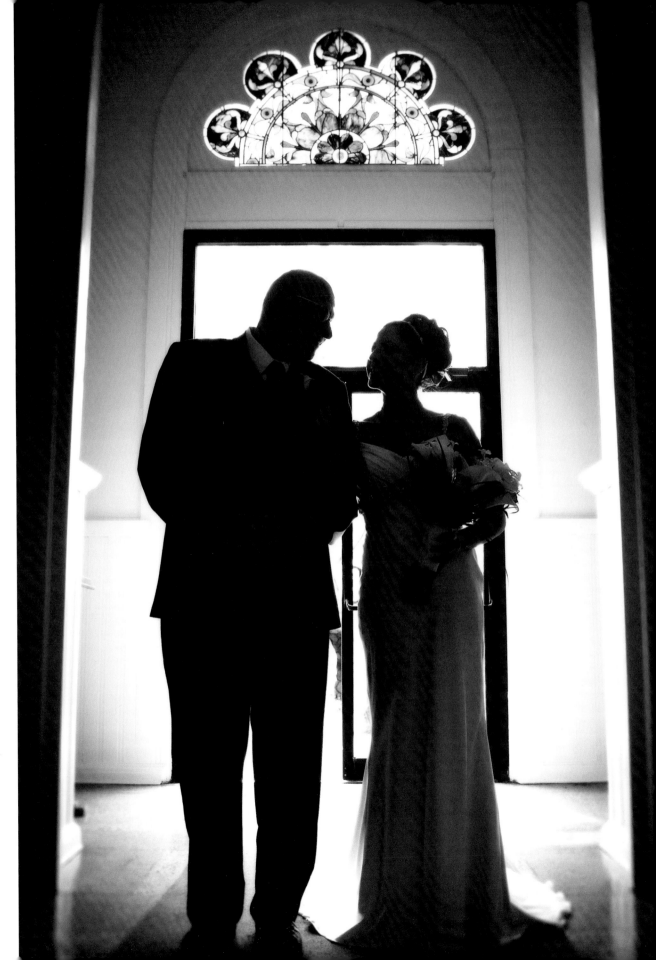

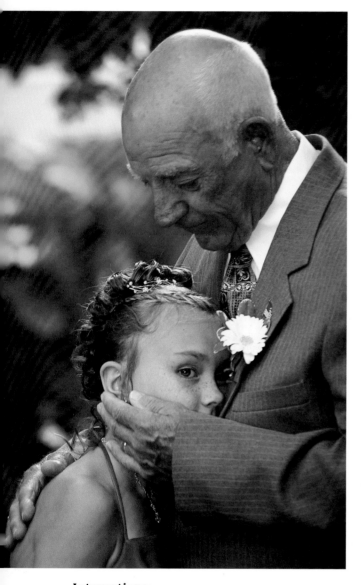

Identify Their Bond

Watching peoples' behavior throughout the day can help you determine which people are likely to interact with one another. If you discover their relationships, you can make sure that you're close at hand if it looks like something might happen between them.

when it's time to socialize with someone else? Being mindful of these tendencies will help you ensure that you are in the right place at the right time to document telling expressions.

Mannerisms

Throughout the wedding day, pay careful attention to people's mannerisms and movements. Often, you'll find that the bride does something repeatedly when she is happy or touched. You may learn that the mother of the bride gets the giggles before telling a story. After a little while, you will have memorized the best angles from which to photograph them.

Interactions

It's important to observe how individuals interact with others. What roles do they play in the interaction? Is Aunt Suzy shy? Does she come out of her shell when her sister approaches? Does Uncle Joey clown around when he's with his kids but show his more dignified, stoic side

Left—Equipment: Canon EOS-1D Mark III with EF 100mm f/2.8L Macro IS USM lens. Exposure: f/2.8 at $^1/_{125}$ second and ISO 125. **Facing page**—Equipment: Canon EOS-1D Mark III with EF 100mm f/2.8L Macro IS USM lens. Exposure: f/2.8 at $^1/_{125}$ second and ISO 125.

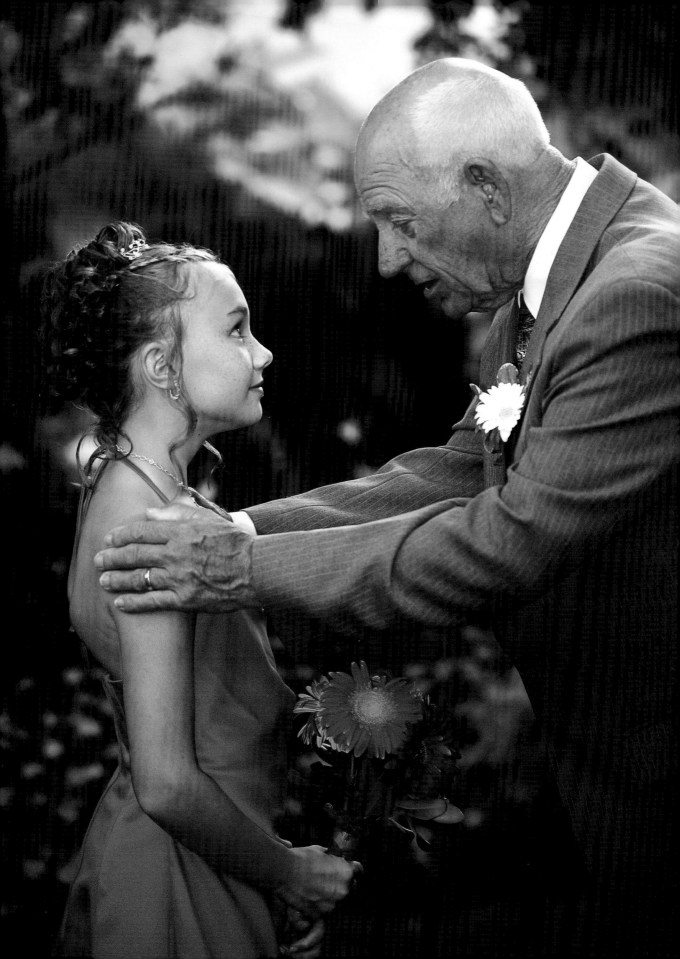

Better Lighting and Backgrounds

The two biggest deterrents to capturing beautiful shots of unscripted moments are lighting and backgrounds. They are almost never conducive to the romantic moment you are trying to document, but you can't jump in and remove an ugly painting or ask the groom to move over without ruining the spontaneity of the moment.

A remedy for this problem is to take the bride and groom to a spot you've chosen ahead of time. Make sure the lighting is controlled and acceptable. Check that you have enough room to back off and still get the angle you have in mind, and inspect the background to make sure it is free of distracting elements. Once the bride and groom are in place, say something inspirational or relaxing to them before leaving them alone. I say something like "I want you to take

five or ten minutes to yourselves. Reflect on the day so far. Share your feelings. Talk to one another. No one can hear you. The bridal party and I will be way over there." Then, break out the longest lens you have and disappear. The couple will enjoy the moments they have alone and make their own intimate moments happen. You'll just be the surveillance. Sometimes, you'll find that the couple doesn't even talk. They communicate everything with a look or gesture. All you have to do is wait for the moments that best convey their emotions.

Authentic Experiences

Some people do not consider shots like these to be true documentary images. I maintain that the emotions are as unencumbered by my input as they are when I capture any other shot. Once the couple is alone in a more photogenic environment, the bridal party will shout something funny, making the bride and groom laugh, the wind will suddenly blow, or the groom will step on the train. When these things happen, your planning goes out the window. You're back to anticipating and reacting to unplanned actions. Be patient and find that decisive moment.

Featured Images

Natural-setting photos are extremely valuable when it comes to designing the wedding album. With these shots in the bag, I know I have beautiful, polished, emotionally resonant images to showcase that will help to round out the album.

Left—Equipment: Canon EOS-1D Mark III with EF 70–200mm f/2.8L IS USM lens. Exposure: f/2.8 at $^{1}/_{400}$ second and ISO 250. Focal length: 100mm. **Facing page, top**—Equipment: Canon EOS-5D Mark III with EF 70–200mm f/2.8L IS USM lens. Exposure: f/2.8 at $^{1}/_{400}$ second and ISO 250. **Facing page, bottom**—Equipment: Canon EOS-1D Mark III with EF 100mm f/1.4L Macro IS USM lens. Exposure: f/4.5 at $^{1}/_{160}$ second and ISO 320.

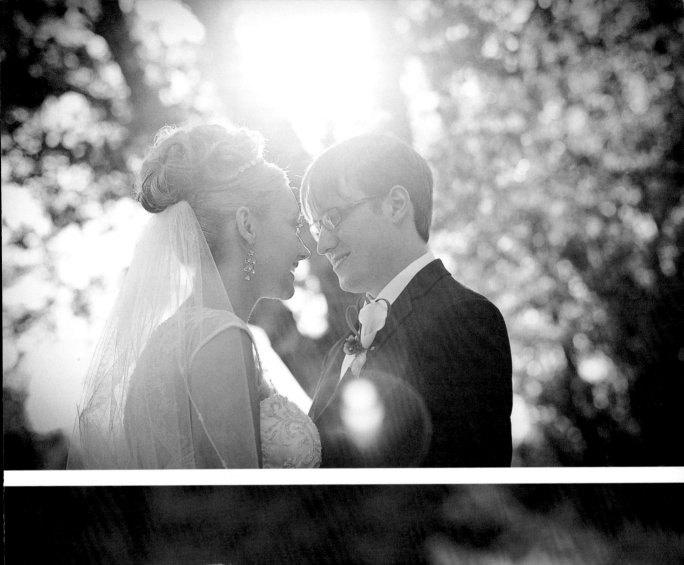
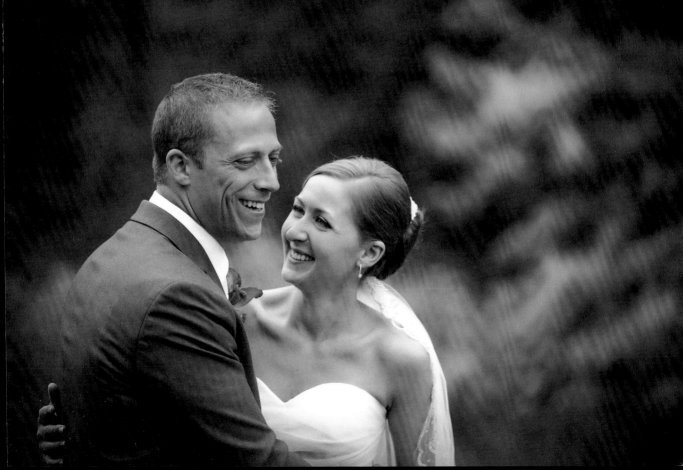

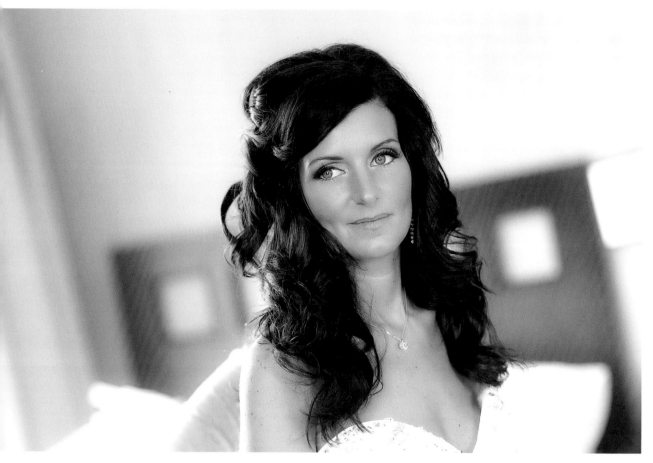

Equipment: Canon EOS-1D Mark III with EF 85mm f/1.8L IS USM lens. Exposure: f/2.5 at $^1/_{160}$ second and ISO 640.

If the bride is comfortable having you with her while she gets ready, you'll have the chance to create some memorable images that are sure to become a treasured part of the album. If you are a woman, you will have a much better shot at getting into the preparatory room. If not, though, take heart! You can still get these shots once she emerges. You are not missing too much in the dressing room, since you are absolutely not, under any circumstances, there to take pictures of her undressed or stepping into the gown! This is not the most flattering or memorable moment—and it can make her uncomfortable.

What you are looking for are split-second moments of realization. This is the time when it finally hits her: she'll be married in a matter of hours. The first moments in the bridal gown are emotional ones for most women. The emotion will linger after she first gets dressed, so even if

you aren't in the dressing area, you'll find she is still glowing when you meet her. The first time she looks in the mirror, she may react emotionally. Just be attentive and follow her movement as soon as you're allowed.

Since we want to avoid mere record-keeping shots, you can try closing in on her face and watching for a revealing expression. Also, watch the way her newly styled hair moves in the light. Capture the details of her dress all the way around. Pay attention to what her hands are doing. Is she fidgeting with her dress or engagement ring? Is she nervously feeling for jewelry and any missed item? These are just a few places you can start to find interesting moments and details.

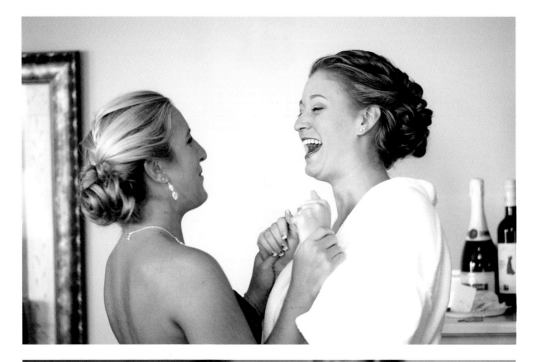

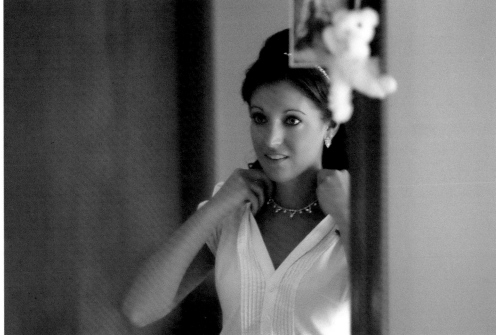

Top—Equipment: Canon EOS-1D Mark III with EF 100mm f/1.8L Macro IS USM lens. Exposure: f/2.8 at $^1/_{60}$ second and ISO 1600. **Bottom**—Equipment: Canon EOS-1D Mark III with EF 100mm f/1.8L Macro IS USM lens. Exposure: f/2.8 at $^1/_{60}$ second and ISO 1250.

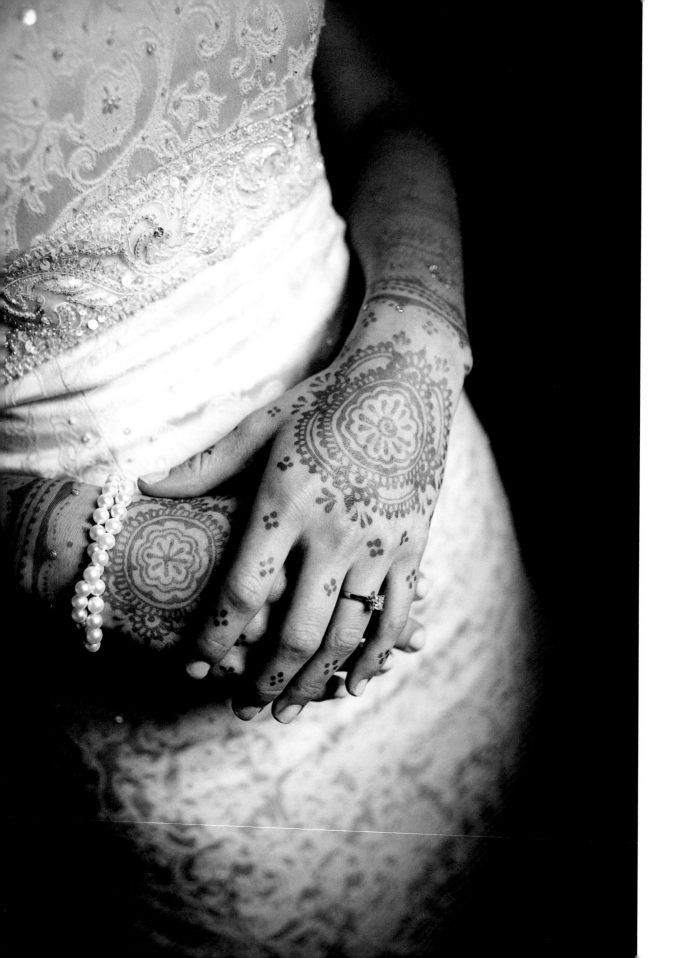

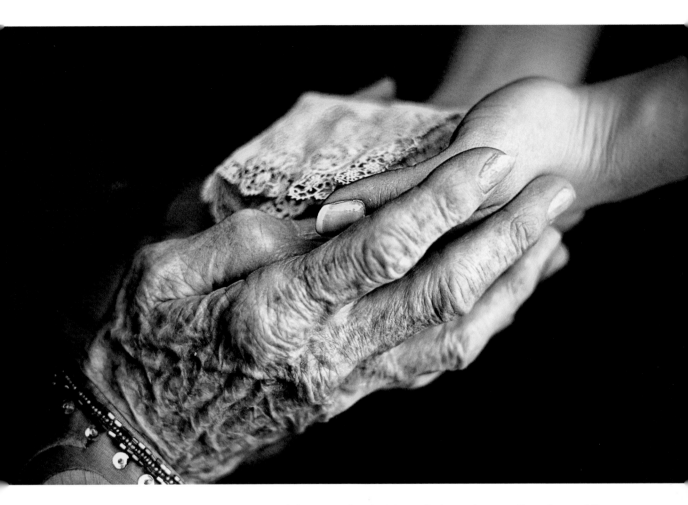

Detail shots are an important aspect of the wedding coverage that can help to document the unique character of a wedding. These shots help to create full and well-rounded coverage of the wedding day, enhancing the romanticism and the overall look you are establishing through your coverage of the day's events.

Whenever you have a spare moment, get in the habit of filling it by creating artistic close-ups of all the details the bride worked on so tirelessly when preparing for her wedding. All of the decisions she's made regarding the wedding are important to her. If you aren't sure of what those details may be, pay attention to what the bride and her family are saying about the things in the environment.

Facing page—Equipment: Canon EOS-1D Mark III with EF 24–70mm f/2.8L IS USM lens. Exposure: f/2.8 at ¹/₆₀ second and ISO 1600. **Above**—Equipment: Canon EOS-1D Mark III with EF 50mm f/1.4L IS USM lens. Exposure: f/1.8 at ¹/₅₀₀ second and ISO 200.

Details: The Dress

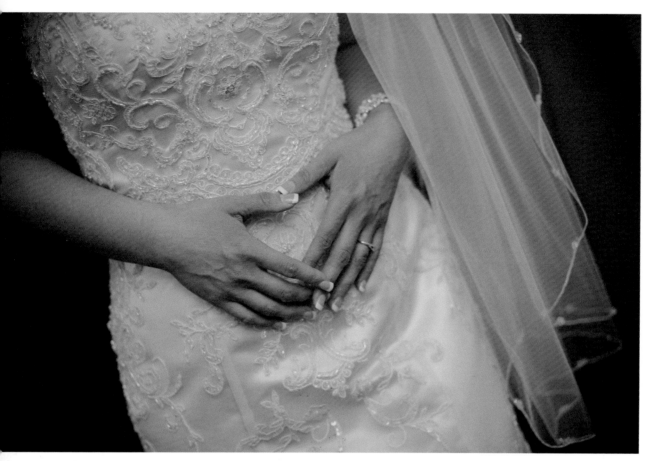

Equipment: Canon EOS-1D Mark III with EF 50mm f/1.4L IS USM lens. Exposure: f/2 at $^1/_{160}$ second and ISO 800.

Critical Shots

There is no denying that the dress is one of the most important elements of the wedding day. Every bride-to-be puts tremendous time and effort into finding just the right dress— the one that fits and flatters her best, suits the theme or style of the wedding, and speaks to the woman she is.

Due to its star status, you'll need to be sure to get numerous detail shots of the bride's dress, from full-body photos to close-up images that highlight the most minute, beautiful details.

Texture and Detail

Natural light will be your greatest asset when photographing the dress. You want to capture true color and light the delicate details softly. When working with white, your number-one priority is to avoid overexposure. Sometimes a

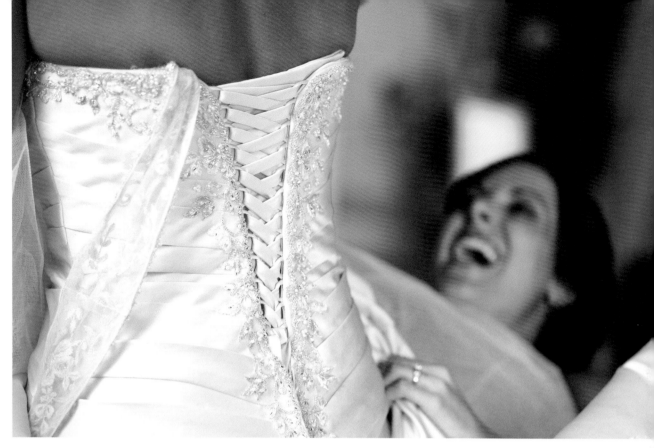

Above—Canon EOS-1D Mark III with EF 85mm f/1.8L IS USM lens. Exposure: f/2 at $^1/_{80}$ second and ISO 320. **Right**—Canon EOS-1D Mark III with EF 50mm f/1.4L IS USM lens. Exposure: f/2 at $^1/_{80}$ second and ISO 1600.

All That Glitters

It's a good idea to zoom in and get a close-up shot of the detail in the bride's gown. You can bet that the intricate beading and other design elements were important to her when she made her selection. Let her know that you've noticed those breath-taking details too.

flash can be effective when trying to capture a sparkle in the rhinestone detailing of the gown.

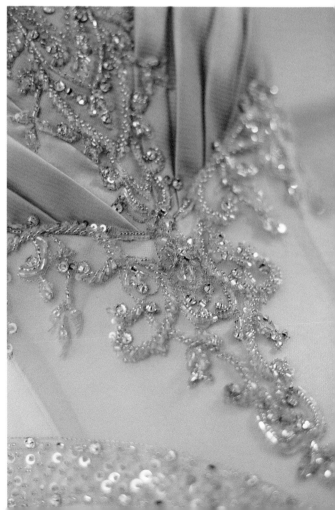

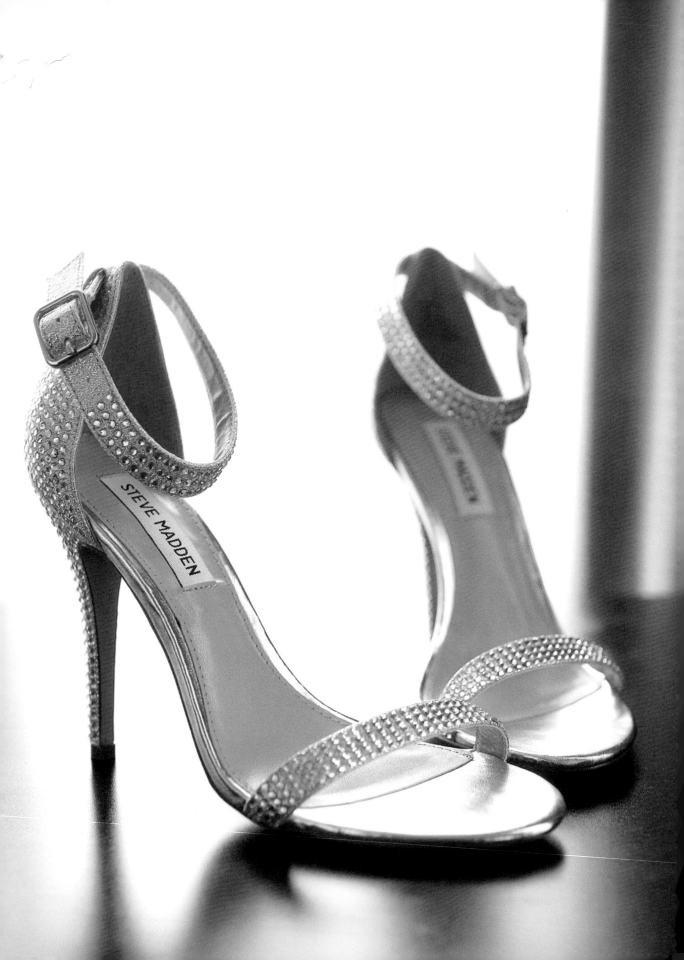

The bride's personal effects are great subjects for detail shots. The dress is, of course, the pinnacle of interest on the wedding day, but it's the first of many details worth photographing. For example, I often hear brides and bridesmaids remarking about their shoes or matching pedicures. They are happy to show off their feet for a photo, and they get a kick out of it. Make it your goal to incorporate these things in an elegant way. Each detail will bring a smile to the bride's face later on.

Brides often add a personal flair by including family heirlooms that are rich in personal history. Inquire about hairpins, handkerchiefs, or any other items that look as if they might be significant. They often have great stories attached to them, which will give you further insight into the family you are getting to know. Bouquets made of brooches are a new way to include heirlooms from many family members.

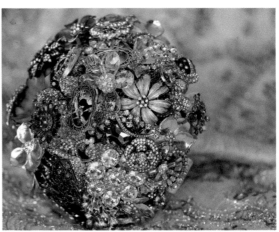

Facing page—Equipment: Canon EOS-1D Mark III with EF 24–70mm f/1.8L IS USM lens. Exposure: f/3.2 at ¹/₁₆₀ second and ISO 640. Focal length: 45mm. **Top**—Equipment: Canon EOS-1D Mark III with EF 100mm f/1.8L Macro IS USM lens. Exposure: f/2.8 at ¹/₆₀ second and ISO 250. **Bottom**—Equipment: Canon EOS-1D Mark III with EF 100mm f/1.8L Macro IS USM lens. Exposure: f/2.8 at ¹/₂₅₀ second and ISO 800.

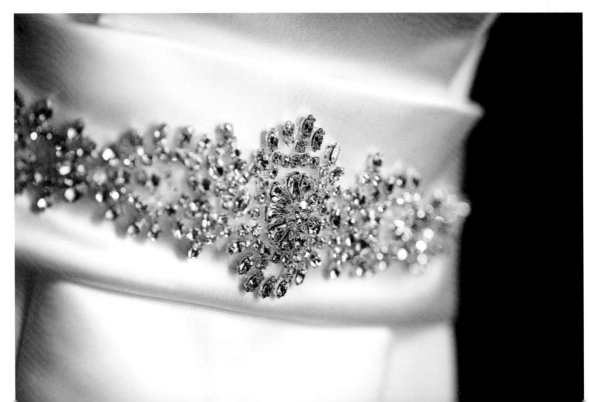

Details: The Flowers

The flowers are an important detail in every wedding, and they are chosen with a great deal of care. Be certain to shoot them early in the day to avoid any wilting or browning. No one will appreciate a close-up of a dying rose.

Remember: you are selling to the bride, and your goal is to touch her emotions. These are all items that she's personally spent time selecting, and you'll be able to arouse a lot of sentiment in her by adding a few marvelous shots.

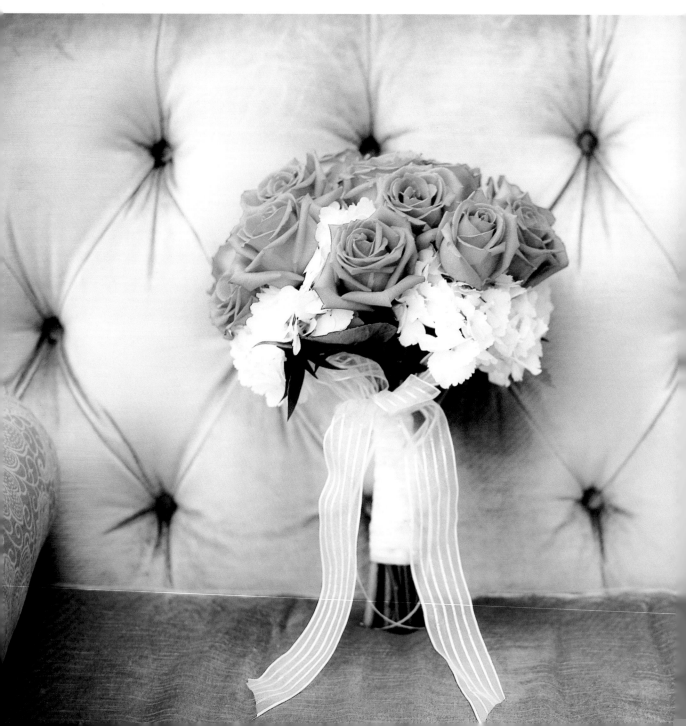

Below—Equipment: Canon EOS-1D Mark III with EF 50mm f/1.4L IS USM lens. Exposure: f/2 at $^1/_{200}$ second and ISO 800. **Top right**—Equipment: Canon EOS-1D Mark III with EF 24–70mm f/2.8L IS USM lens. Exposure: f/2.8 at $^1/_{60}$ second and ISO 1250. Focal length: 24mm. **Bottom right**—Equipment: Canon EOS-1D Mark III with EF 100mm f/1.8L Macro IS USM lens. Exposure: f/2.8 at $^1/_{1600}$ second and ISO 400.

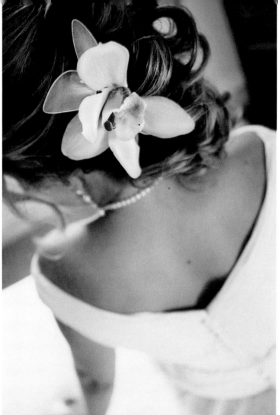

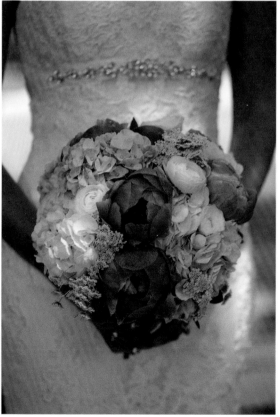

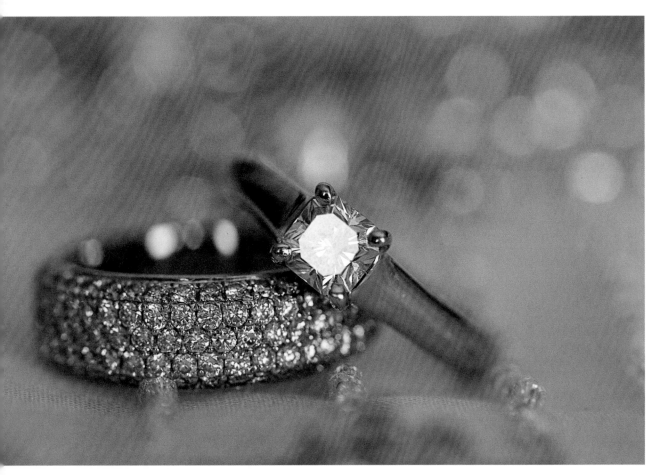

Equipment: Canon EOS-1D Mark III with EF 100mm f/1.4L Macro IS USM lens. Exposure: f/4.5 at $^1/_{60}$ second and ISO 1000.

The Unbreakable Vow

The rings are a symbol that a couple has vowed their eternal love to one another. Therefore, they speak volumes about the significance of the couple's union. Their unique design speaks volumes about the couple's personalities too, so be sure to get some high-quality images of them. If both rings aren't present at the start of the day (often the best man is assigned to keep them), you can begin by photographing the bride's engagement ring on its own. That is usually the most photogenic ring and marks the start of the wedding affair. Once you get both wedding rings together, decide how you would like to photograph them. You may include the flowers, hands, or some other special detail that speaks to their specific theme.

Right—Equipment: Canon EOS-1D Mark III with EF 100mm f/2.8L Macro IS USM lens. Exposure: f/4.5 at ¹/₆₄₀ second and ISO 400. **Below**—Equipment: Canon EOS-1D Mark III with EF 100mm f/2.8 Macro IS USM lens. Exposure: f/5.6 at ¹/₈₀ second and ISO 1000.

Tips for Success

Since rings are tiny, make sure to use the correct equipment and settings in order to capture a technically beautiful image. Use an aperture than ensures that most of the facets of the rings are in focus. Think of the depth between the diamond in its setting and the band itself. It is too great a space to use f/1.4. Make sure that the settings and lenses that you choose benefit a detailed, close-up shot and allow you to achieve a sharp focus.

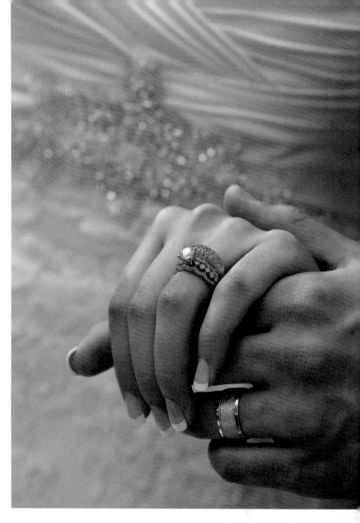

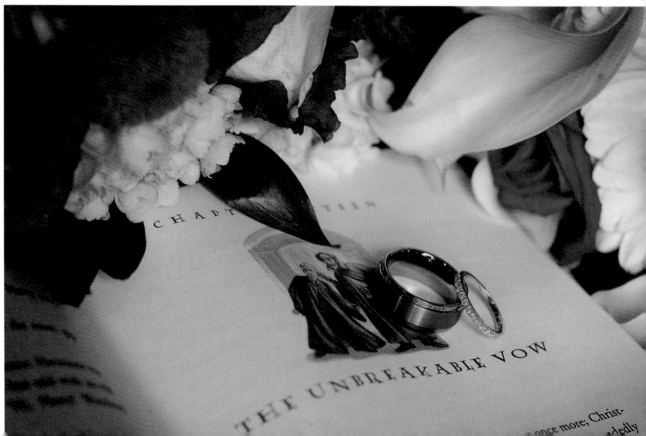

Details: The Ceremony

At the ceremony, taking photographs of any personal touches is important. If there is a homemade chuppah in a Jewish ceremony or a mandapa in an Indian one, a photograph of that element of the ceremony will hold great meaning for the bride and groom and their families. In a Christian ceremony, decorations may be placed on the altar or pews. There will likely be a unity candle or sand, symbolic of the two families being joined in unison. There are usually programs, as well as candles or photos in memory of loved ones. These details are all highly personal and have been paid the greatest attention by the bride, the groom, and their families. Creating beautiful photos of these special touches will help you tell the story of the day and will serve as an emotional trigger for those who will view the album. When they see that you've captured not just the people that matter but also the symbolic elements used in the ceremony, the family will be thankful for your attention to detail.

Left—Equipment: Canon EOS-5D Mark III with EF 24–70mm f/2.8L IS USM lens. Exposure: f/2.8 at $^1/_{200}$ second and ISO 2500. Focal length: 24mm. **Right**—Equipment: Canon EOS-5D Mark III with EF 100mm f/2.8L Macro IS USM lens. Exposure: f/2.8 at $^1/_{1000}$ second and ISO 3200. **Facing page**—Equipment: Canon EOS-1D Mark III with EF 50mm f/1.4L IS USM lens. Exposure: f/2.0 at $^1/_{100}$ second and ISO 1250.

| # Details: The Reception

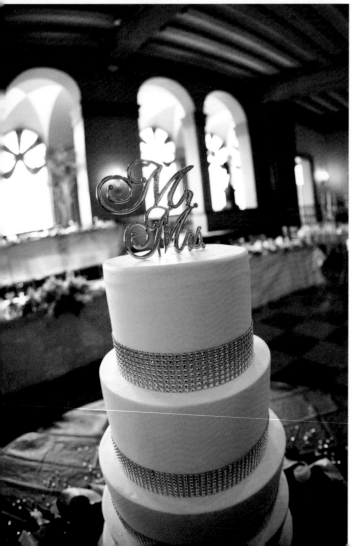

The reception is often filled with even more details than the previous parts of the day. Receptions are where the bride's full vision comes together. She has selected the perfect cake, champagne flutes, favors, chair covers, place cards, and centerpieces with the utmost care. It is your job to highlight these details and make them look as beautiful as possible.

Consider macro shots of small items like favors, crystals, or the delicate detailing of the cake.

Try to get into the room before the guests arrive. Doing so will allow you to have free reign over everything and you can also take an overall shot of the empty room. If there are candles on the tables, make sure to wait or re-do those shots once the candles are lit. Try to capture close-ups that make every detail count. Consider macro shots of small items like favors, crystals, or the delicate detailing of the cake. You will be well-served by capturing both a wide overall and an extreme close-up of everything at the reception. Some details will be highlighted as the night progresses, but most will be documented as soon as you arrive.

Top—Equipment: Canon EOS-1D Mark III with Tokina 11–16mm 85mm f/1.8L IS USM lens. Exposure: f/3.2 at $^1/_{25}$ second and ISO 1600. **Bottom**—Equipment: Canon EOS-1D Mark III with EF 15mm f/2.8 Fisheye lens. Exposure: f/2.8 at $^1/_{60}$ second and ISO 2000. **Facing page**—Equipment: Canon EOS-1D Mark III with EF 85mm f/1.8L IS USM lens. Exposure: f/2 at $^1/_{400}$ second and ISO 1000.

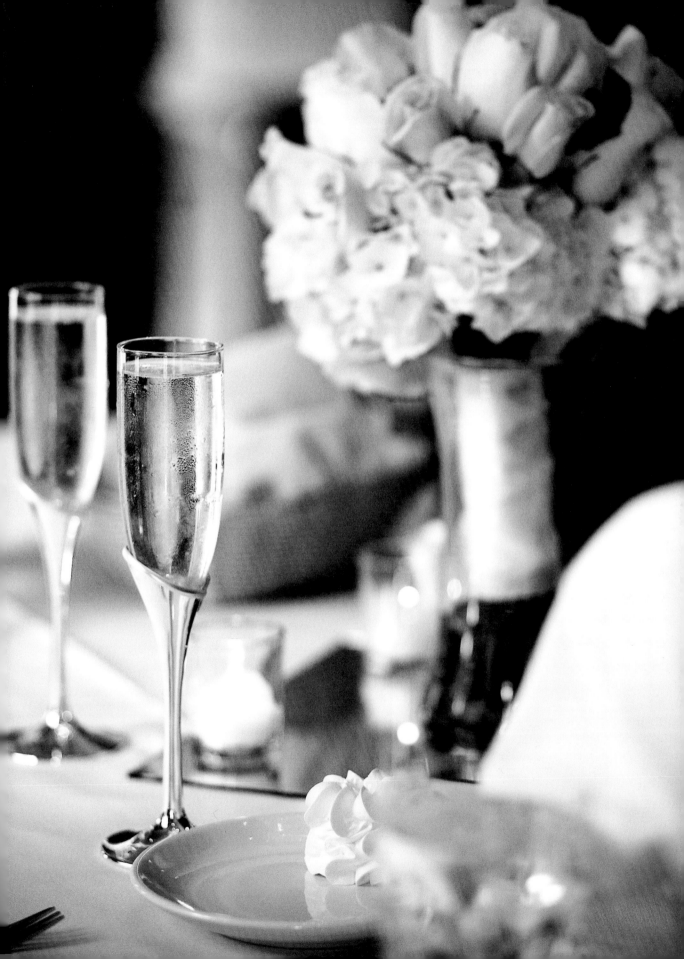

Details: Found Objects

Found objects can be a great addition to your compositions and can help you create images that show the unique qualities of each event.

There is no way to know when or where you will find that certain something to photograph. Keep your eyes open, and don't discount anything without thinking it through. If you see flowers growing in the grass, wait by them until you get a clean shot or use them to enhance

Utilize architectural details like high archways and design features like chandeliers to your advantage as well . . .

your traditional posed shots for the day. If someone leaves behind a program or a box of tissues, that can tell a great story by itself—even without your subject in it.

A cutout in a bench can create a frame for a picture, a fence can help frame a portrait, and a doorway could add depth to your shot. Doorways in particular seem to add a feeling of voyeurism, which really helps to drive home the feeling that you're capturing a behind-the-scenes look at the day.

Look for personalized touches such as handwritten notes or cards sent by the groom. Sometimes a decorative sign can become the subject of your shot with the bride and groom as the background. Utilize architectural details like high archways and design features like chandeliers to your advantage as well, giving the wedding an even more grand overall look.

Top—Equipment: Canon EOS-1D Mark III with EF 24–70mm f/2.8L IS USM lens. Exposure: f/2.8 at $^1/_{2000}$ second and ISO 400. **Bottom**—Equipment: Canon EOS-1D Mark III with EF 100mm f/2.8L Macro IS USM lens. Exposure: f/5 at $^1/_{160}$ second and ISO 800. **Facing page**—Equipment: Canon EOS-1D Mark III with 15mm fisheye f/2.8L IS USM lens. Exposure: f/2.8 at $^1/_{25}$ second and ISO 500.

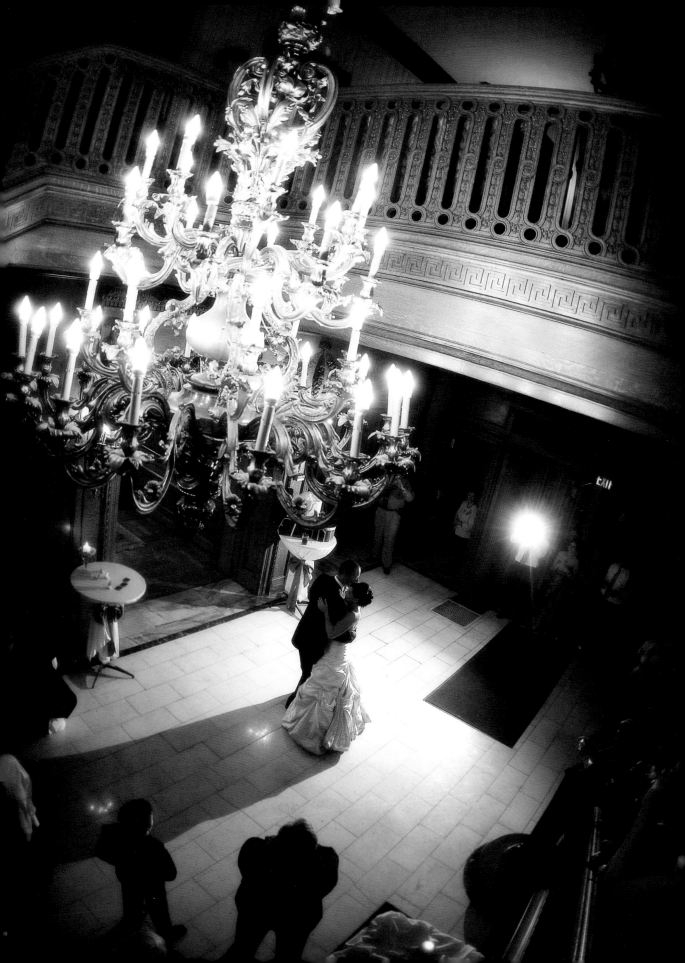

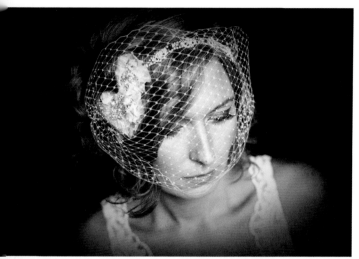

Since the bride is your main focus throughout the wedding day, you will need to be constantly on the lookout for ways to capture a photojournalistic portrait of her. Your goal is to create a multitude of beautiful and flattering images without exhausting the same (or similar) poses all day long. Work to differentiate each shot from the next. Repetitive, nearly identical shots don't sell well—they aren't very interesting to look at—and they can result in negative feedback and harm your future word-of-mouth advertising.

Work to differentiate each shot from the next. Repetitive, nearly identical shots don't sell well . . .

As the day unfolds, pay close attention to the details of her bridal selections and see how you can capture them in a pleasing way. When you create a portrait that's both in the moment and flattering to her bridal style, you'll score a home run.

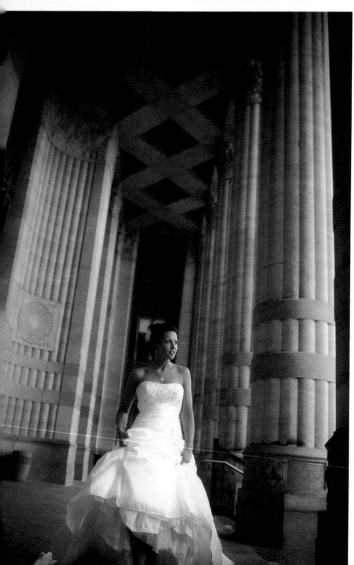

Top—Equipment: Canon EOS-1D Mark III with EF 50mm f/1.4L IS USM lens. Exposure: f/2.2 at $^1/_{320}$ second and ISO 800. **Bottom**—Equipment: Canon EOS-1D Mark III with EF 24–70mm f/2.8L IS USM lens. Exposure: f/2.8 at $^1/_{160}$ second and ISO 250. Focal length: 24mm. **Facing page**—Equipment: Canon EOS-1D Mark III with EF 24–70mm f/2.8L IS USM lens. Exposure: f/2.8 at $^1/_{250}$ second and ISO 400. Focal length: 46mm.

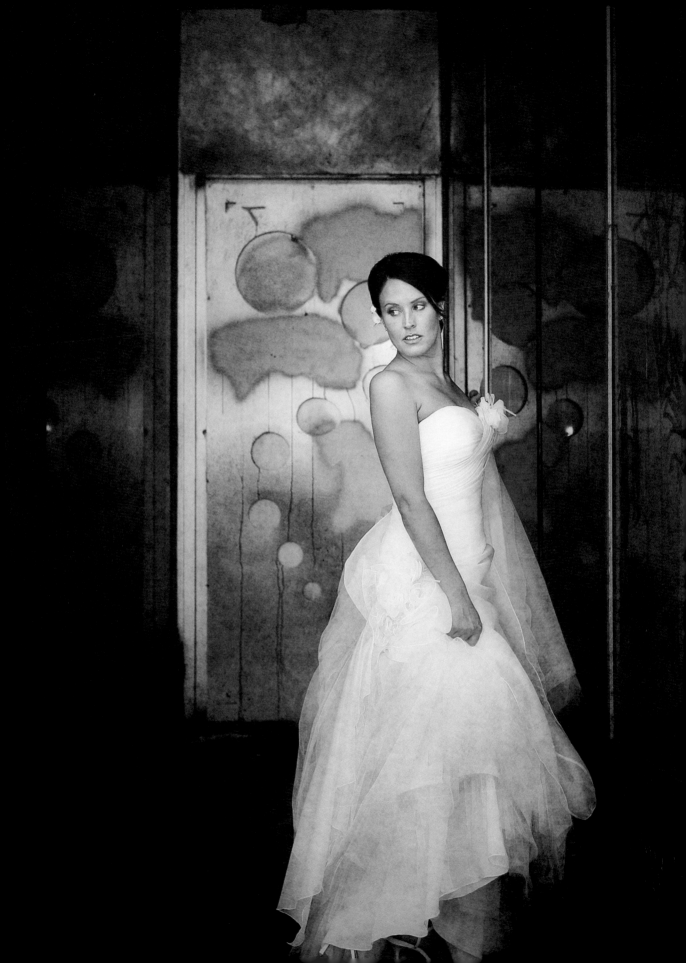

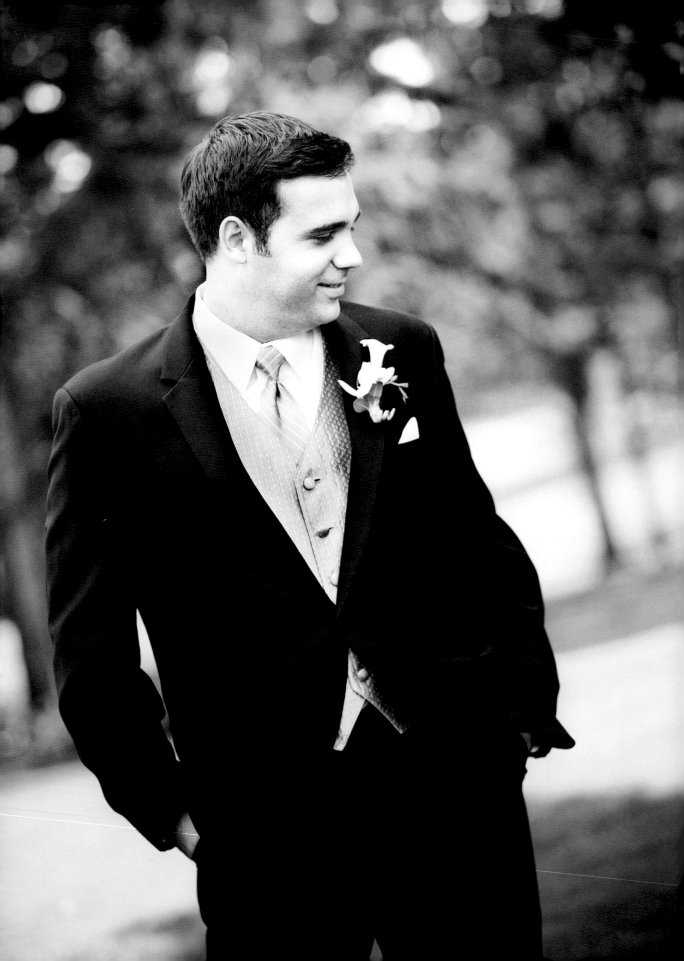

Never overlook the bride's co-star, the groom. His important role must be documented in a flattering and creative way, and your images of him should balance out your bridal portraits. These shots will sell well to both families (particularly the mother of the groom). It's important not to end up with an album that is 99 percent bridal portraits and details, because that can make you appear inexperienced.

Look for ways to capture the groom as he is caught up in the moment or strive for relaxed portraits. Find as many special moments for the groom as you have for the bride. If you are struggling with your natural candids, direct him to a photo-friendly spot and have him pose in a way that suits his personality. You might also have the bride and/or bridal party off to the side interacting with him. This can help inspire a natural moment and help him relax.

Grooms have personal details that they have chosen carefully, just as the bride does. Photograph cuff links, boutonnières, pocket watches, wristwatches, and rings attentively. He will appreciate his personality being represented. Utilize sunglasses and fun accessories with a groom who needs a little help getting over his nerves.

Facing page—Equipment: Canon EOS-1D Mark III with EF 85mm f/1.8L IS USM lens. Exposure: f/2 at $^1/_{3200}$ second and ISO 800. **Left**—Equipment: Canon EOS-5D Mark III with EF 24–70mm f/2.8L IS USM lens. Exposure: f/2.8 at $^1/_{400}$ second and ISO 250. Focal length: 70mm. **Right**—Equipment: Canon EOS-1D Mark III with EF 24–70mm f/2.8L IS USM lens. Exposure: f/8 at $^1/_{500}$ second and ISO 200. Focal length: 57mm.

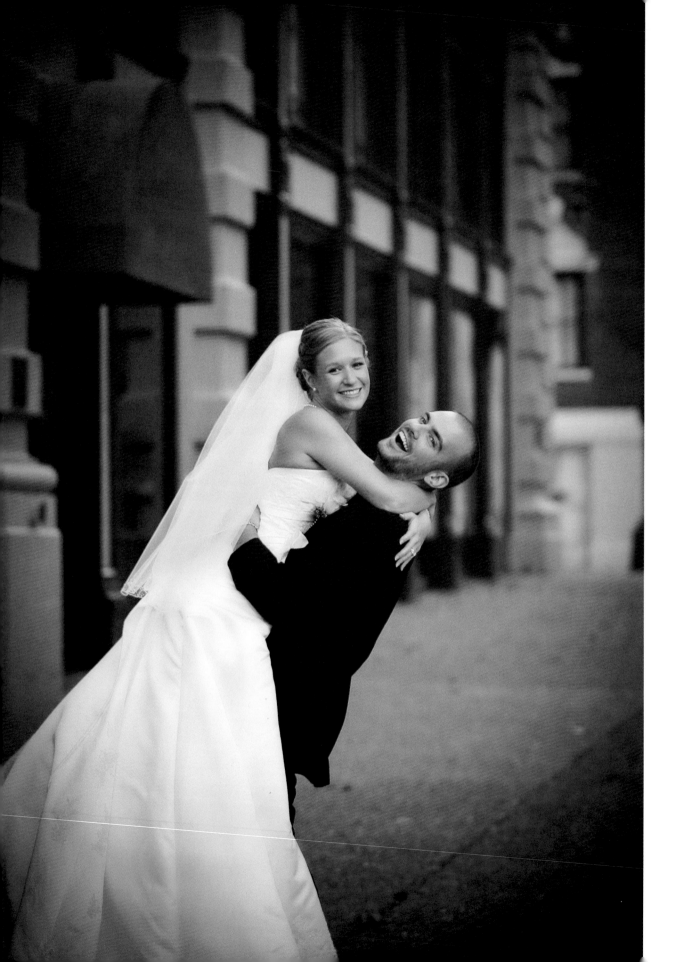

I t's important to avoid focusing too closely on individual portraits and details. While images like these enhance your overall product and give your work its point of view and style, they cannot create a complete picture of the wedding. Nothing is more important than images of the couple together. You must be sure to capture a wide array of image looks covering a range of emotion to show your skill and please both families.

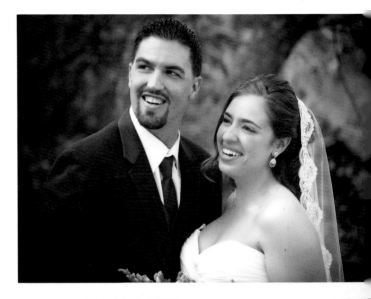

> You can never go home empty handed, so it's important to make sure to cover your bases.

Traditionally posed photographs are easily obtained through your direction. The candid photographs of the bride and groom having fun will take a little more work. You can create them two ways: either photojournalistically (completely untouched by your posing skill) or in a natural and candid approach, where you give subtle directions and control the background, letting their responses naturally unfold. A natural, relaxed setup can be a great benefit on a day when you're not getting as many truly candid moments as you'd like. You can never go home empty handed, so it's important to make sure to cover your bases. Make sure you return with the product you promised to provide.

Facing page—Equipment: Canon EOS-1D Mark III with EF 100mm f/2.8L Macro IS USM lens. Exposure: f/2.8 at $^1/_{500}$ second and ISO 800. **Top**—Equipment: Canon EOS-1D Mark III with EF 100mm f/2.8L Macro IS USM lens. Exposure: f/2.8 at $^1/_{500}$ second and ISO 400. **Bottom**—Equipment: Canon EOS-1D Mark III with EF 100mm f/2.8L Macro IS USM lens. Exposure: f/2.8 at $^1/_{80}$ second and ISO 200.

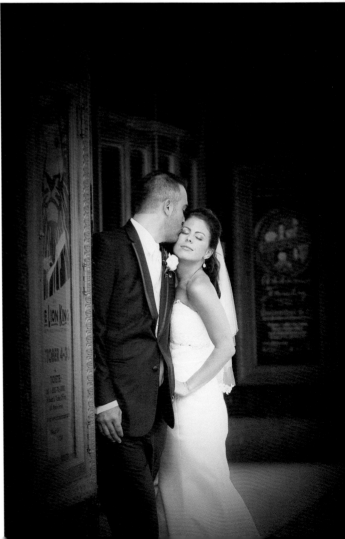

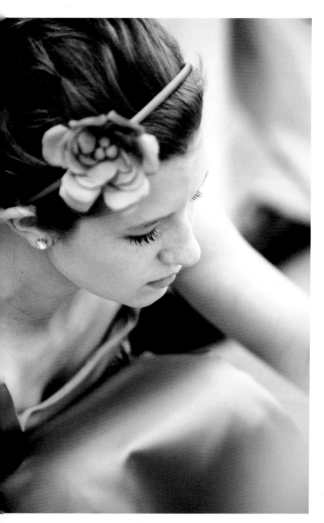
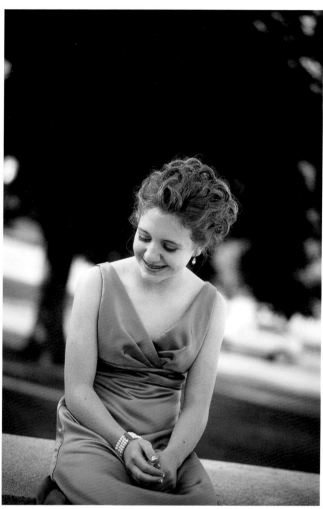

Left—Equipment: Canon EOS-1D Mark III with EF 70–200mm f/2.8L IS USM lens. Exposure: f/2.8 at $^1/_{80}$ second and ISO 200. **Right**—Equipment: Canon EOS-1D Mark III with EF 100mm f/2.8L Macro IS USM lens. Exposure: f/2.8 at $^1/_{320}$ second and ISO 160.

Key Players

It's important to capture natural moments of the bridal party too because they are all key players in the event. Each of these individuals has been asked to stand up for the bride or groom because they are important people in their lives. Your clients will appreciate images of them enjoying the day and having fun, so they can look back and see that the day was indeed a success.

Individual Portraits

As the day progresses, try to create a single portrait of as many members of the bridal party

as possible. The bride and groom will enjoy seeing them, and they will be thankful for great portraits of their friends and family, because it is not often that adults have their portraits taken. It is also rare to have a photojournalistic portrait created, so this is a wonderful opportunity to surprise everyone with one. That can translate into extra image sales, since you can sell that image to the individual featured in the portrait, in addition to the bride and her family.

Group Candids

It is also important to remember not to focus solely on individual portraits. Your mission is to capture the festivities of the wedding, and the best way to accomplish that is to capture photos of groups of people enjoying themselves. It's much harder to capture the perfect moment when there are many people moving in one shot, but when you do, the bride and groom will really be able to see how much fun everyone was having on their big day.

> Your mission is to capture the festivities of the wedding . . . to capture photos of groups of people enjoying themselves.

Equipment: Canon EOS-1D Mark III with EF 100mm f/2.8L Macro IS USM lens. Exposure: f/2.8 at $^1/_{300}$ second and ISO 200.

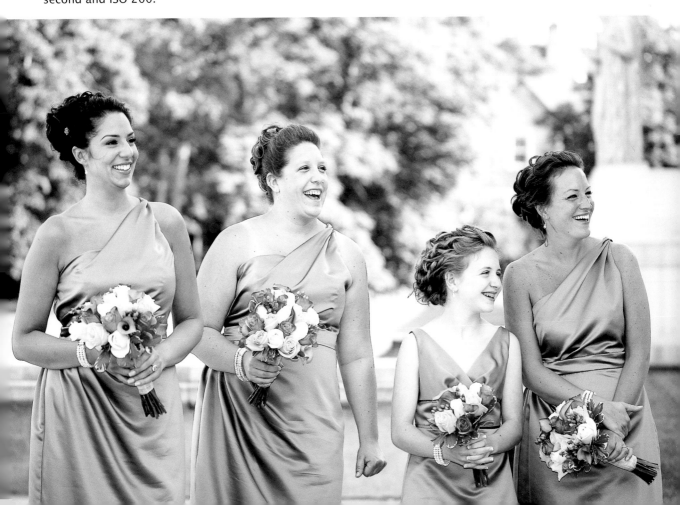

35 | Key Shots: The Parents

We've covered the importance of capturing images of symbolic and otherwise meaningful objects on the wedding day. But, of course, you'll need to devote some time to photographing the people who have come to share in the big day. So, who should you keep an eye on? How many frames should you spend?

> It is a good bet that the parents will play a big role in the day and mean a great deal to the bride and groom.

At most weddings, it is a good bet that the parents will play a big role in the day and mean a great deal to the bride and groom. This is not a guarantee, however. The first thing you need to do is a little probing. Find out if all of the parents are in attendance and identify them. Pay attention to how they interact with the bride. You will often encounter estranged relationships or some that are simply just not that close. On the opposite end of the spectrum, some relationships are very close. Know what you are dealing with in order to know whom to compose portraits of throughout the day.

For example, if the bride makes her mother the matron of honor, they obviously enjoy a close relationship and you will benefit from

Equipment: Canon EOS-1D Mark III with EF 100mm f/1.4L Macro IS USM lens. Exposure: f/2.8 at ¹/₅₀ second and ISO 1600.

taking a lot of frames of the mother having a good time. You will also know to compose a lot of shots with the mother and daughter together, sharing moments. Alternately, if the bride does not ask her father to walk her down the aisle, or perhaps you overhear her talking about how much he upsets or annoys her, then you know the relationship does not warrant dozens of photojournalistic portraits.

Your main goal is to produce images of the people, places, and things that serve as an emotional trigger . . .

If the parents are divorced, do not spend time composing a shot of the two of them together. On the other hand, if they have enjoyed a thirty-year marriage, make sure to try to get a shot of the two of them laughing together. It is a moment that both they and the bride will value—and composing a shot of the two of them makes it worth more than a shot of just one of them. Its perceived value is higher. No one ever wants to leave someone out. It is very important to cover the whole family at an event. Everyone who shares a close relationship with your clients should be equally represented.

It is important to spend your shots wisely. Don't waste valuable time overshooting any single person, especially if you've learned that the couple isn't likely to purchase an 8x10-inch print of that individual after the wedding. Remember, your main goal is to produce images of the people, places, and things that serve as an emotional trigger for the viewer. Make sure you never forget who you are selling to and the reason why he or she might purchase the photo

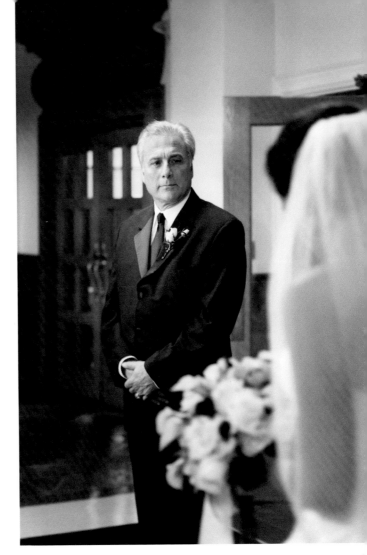

Equipment: Canon EOS-1D Mark III with EF 50mm f/1.4L IS USM lens. Exposure: f/2.2 at $^1/_{125}$ second and ISO 1600.

you are creating. It is not an exact science in any way, but giving it some thought may just help boost your sales and result in some positive feedback.

Key Shots: Children

Photos of a flower girl or a ring bearer can add immeasurable joy to a wedding album. They bring an innocence and spectacular cuteness to your pictures. They incite the "Aww!" response from viewers and add another perspective to the wedding. The children included in

Photographing kids can prompt you to take a traditional shot from an innovative angle.

the wedding party were selected by the bride and groom for a reason, so you want to afford enough time to get good shots of each of them. In formals, they are often the hardest to pose and (when tired) can be the hardest to elicit a smile from. Capturing natural moments is an ideal way to transcend this boundary. Follow the children around and use a zoom lens where possible. Make sure not to discount any activity.

Furthermore, the way that the kids interact with guests can add impact to your album. A photo of them watching the bride and groom or a shot of the mother of the bride playing with them tells a great story and adds resonance to the final collection of photos. Also, because they tend to be on the short side, photographing kids can prompt you to take a traditional shot from an innovative angle. Keep an eye on children at all times.

Below—Equipment: Canon EOS-1D Mark III with EF 50mm f/1.4L IS USM lens. Exposure: f/2.8 at $^1/_{200}$ second and ISO 400. **Facing page**—Equipment: Canon EOS-1D Mark III with EF 50mm f/1.4L IS USM lens. Exposure: f/2 at $^1/_{1250}$ second and ISO 800.

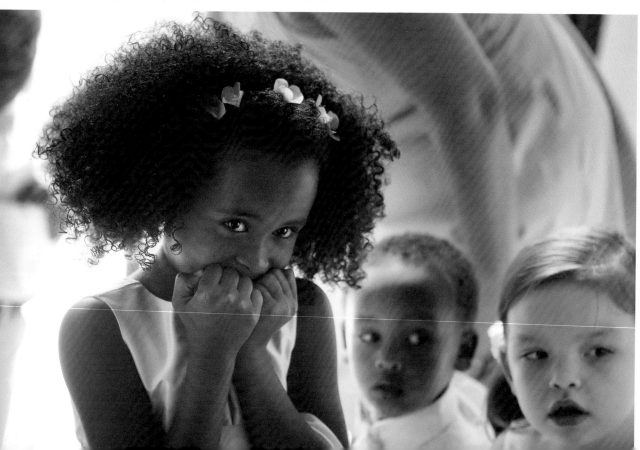

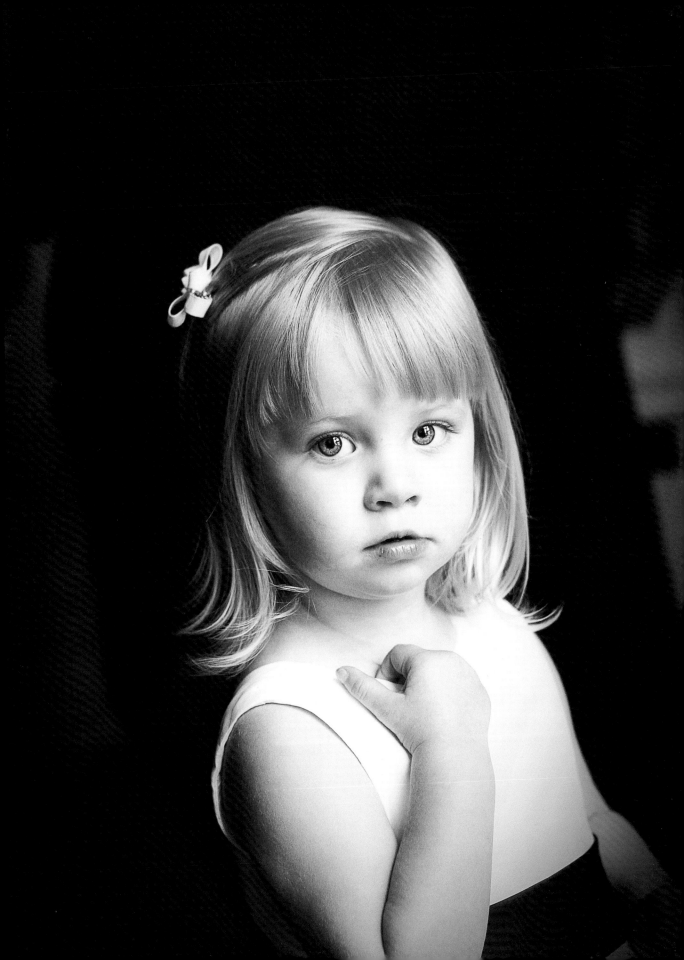

We know that parents and children play an influential role in the wedding day. It's important to pay attention to them and create a natural portrait of each one enjoying the day if you can. You will continuously be watching for and responding to spontaneous moments for them, but you will also benefit from keeping an eye on other important people. Grandparents, godparents, aunts, uncles, nieces, and nephews are all also important players in a wedding. You must identify them and find out how close of a relationship they share with the bride and groom. Are they close enough to be asked to be in the wedding or read a selection at the ceremony? Did they help the bride get ready? On the other hand, you may find that they live out of town. This could go either way—perhaps they don't see each other aside from weddings

> Grandparents, godparents, aunts, uncles, nieces, and nephews are all also important players in a wedding.

and funerals and barely have a relationship with the bride. Or, they could have gone to great expense and effort to attend the wedding, which will mean a lot the family. Keep your ears open and try to determine who is most important.

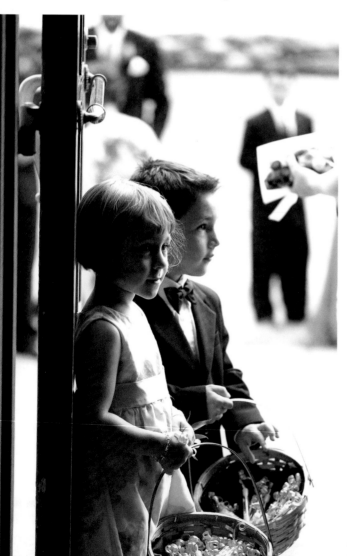

Left—Equipment: Canon EOS-1D Mark III with EF 100mm f/2.8L Macro IS USM lens. Exposure: f/2.8 at $^1/_{1600}$ second and ISO 1250. **Below**—Equipment: Canon EOS-5D Mark III with EF 50mm f/1.4L IS USM lens. Exposure: f/2 at $^1/_{320}$ second and ISO 800. **Facing page**—Equipment: Canon EOS-1D Mark III with EF 50mm f/1.4L IS USM lens. Exposure: f/2.2 at $^1/_{200}$ second and ISO 800.

Natural Light

Shooting natural light is something professional photographers should learn to do whenever possible. When done correctly, it lends a beautiful feeling to your images and gives them a softer, more intimate quality. It sets the scene, adds drama, and can literally present your subject in a flattering light.

Working with natural light also helps you to work unobtrusively. Most subjects will notice a flash going off in their peripheral vision and will turn and look, thereby killing the interaction you are trying so hard to capture. If you can shoot with natural light only, they will be less likely to notice you are there. In a noisy room, they won't even hear your shutter, so you'll be free to shoot away.

Choosing faster lenses (those with wider maximum apertures) will help you when shooting natural light. It's not always possible, but it is something to strive for.

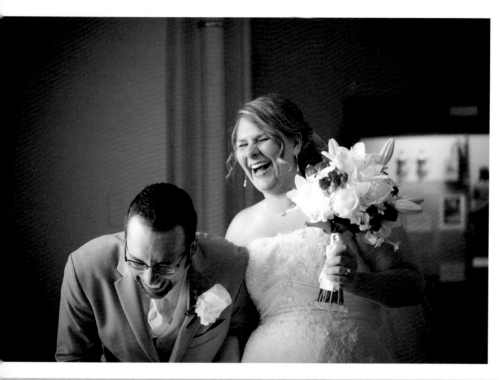

Left—Equipment: Canon EOS-1D Mark III with EF 100mm f/2.8L Macro IS USM lens. Exposure: f/2.8 at $^1/_{250}$ second and ISO 1600. **Facing page**—Equipment: Canon EOS-1D Mark III with EF 24–70mm f/2.8L IS USM lens. Exposure: f/2.8 at $^1/_{800}$ second and ISO 100. Focal length: 34mm.

Zoom Lens Advantages

If you are less than three feet away from your subjects, you're in their personal space. They are not only likely to be aware of you, but looking to you for direction.

Using a zoom lens allows you to stay out of the way and shoot unobtrusively, particularly in a crowded setting. The farther away you can get, the less the subject will be impacted by your presence. An added benefit: shooting from a greater distance with a zoom lens means you can stand in one spot and survey the whole crowd, selectively choosing which scenes are most exciting. You can get a great shot without moving your feet and squeezing through crowds of guests.

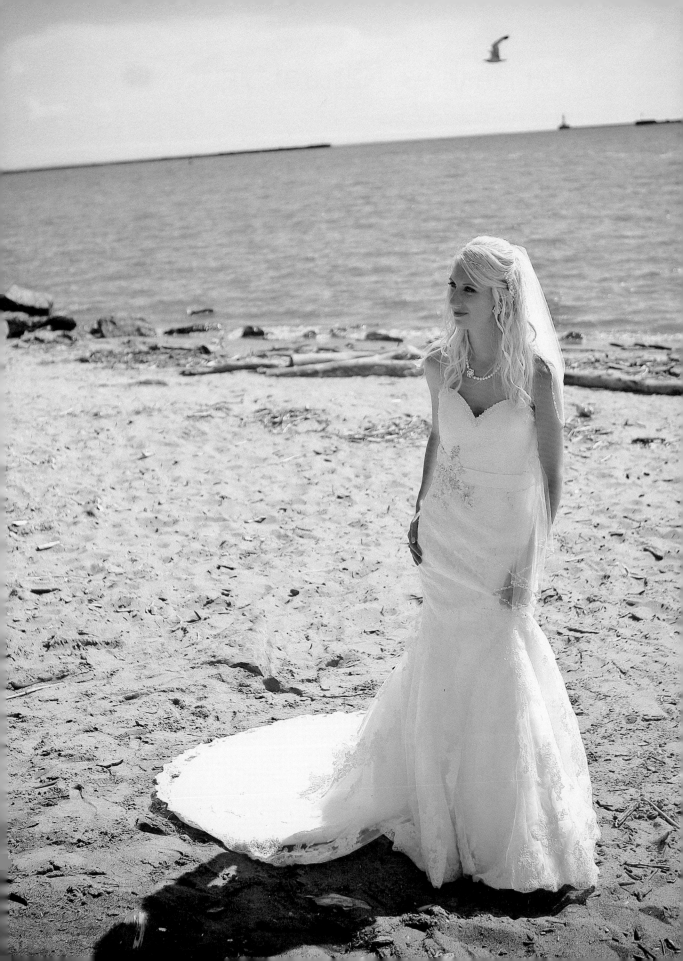

Fill Flash vs. Natural Light

Natural Light

When you are shooting natural, unrehearsed photographs, you must instantly adapt to your changing surroundings and create a beautiful, flattering portrait under the constraints of the circumstances you're in. This can pose quite a challenge sometimes. Whenever possible, position yourself to capture moments with soft, natural lighting. This will give your images a polished and planned quality—they will look almost posed, when in reality, you adapted to your surroundings and made sure you were in the right place at the right time.

Fill Flash

At a wedding, you must work with whatever backgrounds and lighting you encounter. You will need to make quick decisions about what to do in less-than-desirable portrait situations. A fill flash can be your best friend. Though some photographers avoid using flash for fear of creating an artificial, flat lighting effect, adding flash can actually enhance the lighting on your subject.

Learn to use your flash in manual mode before the day of the event so that you will be prepared to introduce flash using a low power setting. This way, you can avoid overexposing your subjects or blasting the room with light.

You want the flash to fill in the shadows on the face or overcome dim lighting, not to blow out important details.

You want the flash to fill in the shadows on the face or overcome dim lighting, not to blow out important details.

Another important point is that using low-level flash to supplement the ambient light will allow you to shoot at a lower ISO. With advances in technology, noise is less a problem at high ISOs than it was in recent years, but it's best to shoot at as low an ISO as the scenario will allow to produce clean, properly exposed, detail-rich images.

Note: The images below and on the facing page were shot with flash fill.

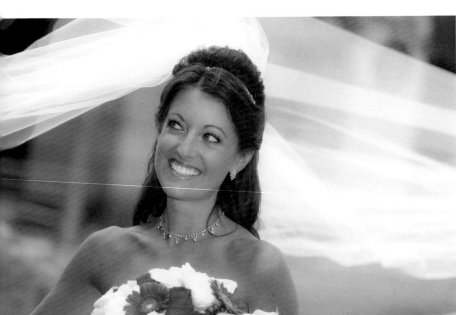

Left—Equipment: Canon EOS-1D Mark III with 100mm Macro f/2.8L IS USM lens. Exposure: f/2.8 at $^1/_{300}$ second and ISO 160. **Facing page**—Equipment: Canon EOS-5D Mark III with EF 70–200mm f/2.8L IS USM lens. Exposure: f/5.6 at $^1/_{80}$ second and ISO 250. Focal length: 125mm.

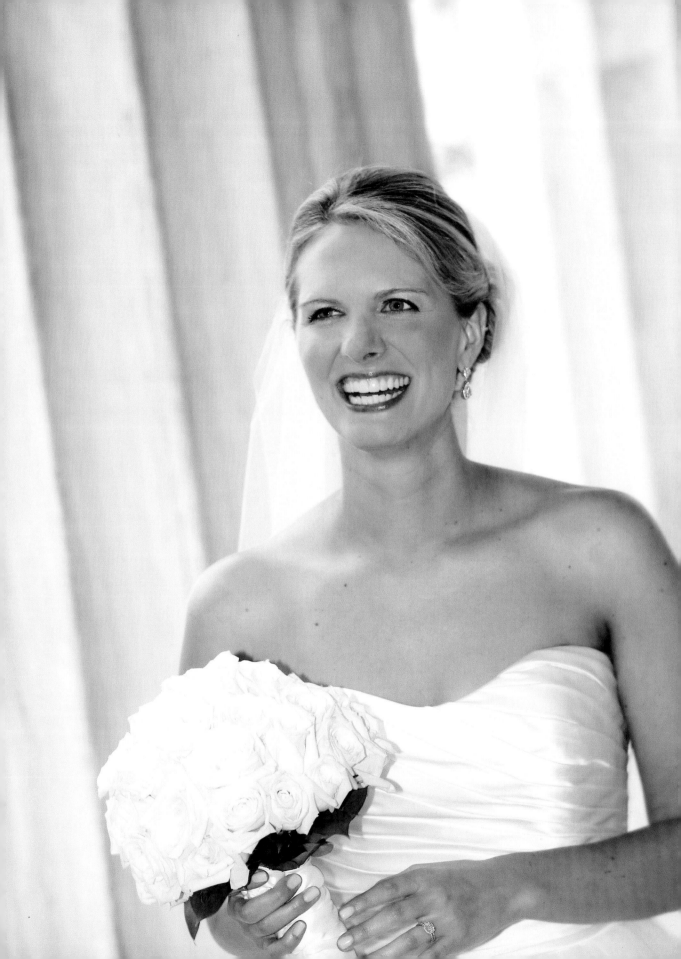

Composition

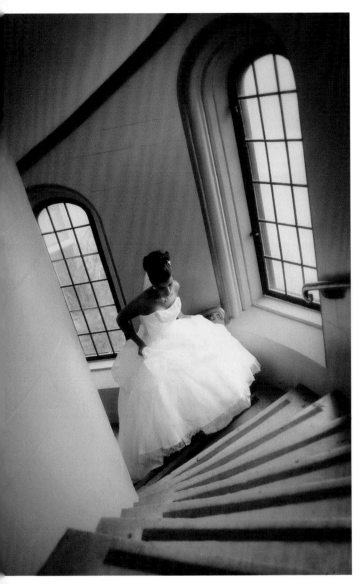

Left—Equipment: Canon EOS-1D Mark III with EF 24–70mm f/2.8L IS USM lens. Exposure: f/2.8 at $^1/_{60}$ second and ISO 1600. Focal length: 24mm. **Facing page**—Equipment: Canon EOS-1D Mark III with EF 24–70mm f/2.8L IS USM lens. Exposure: f/2.8 at $^1/_{40}$ second and ISO 1600. Focal length: 25mm.

correct as possible in-camera. If you capture a moment a little too closely or in a manner that is just too sloppy, you won't be able to correct it after the fact. Being too far away from your subjects also has a negative effect. You may not have enough resolution or depth in the image to salvage the shot. So throughout the wedding, always try to capture your moments as effectively as possible.

Utilize the rule of thirds and take advantage of strong leading lines when you position your subjects. If you see a staircase or building that's got great lines, try lingering near it (hoping to capture an authentic moment) or guide your bride and groom there for a natural, relaxed

If you see a staircase or building that's got great lines, try lingering near it or guide your bride and groom there . . .

pose. Always position your lines so they are leading to the center of the frame, keeping the eye moving. Also, keep horizon lines straight. Select a low or high angle to complement the subject or scene in front of you.

Whether you are photographing photojournalistically or setting up a natural, candid shot, you always need to keep the composition of your shot high on your priority list. Although you can crop to suit your needs in postproduction, you will save yourself time and headaches if you can get the composition as

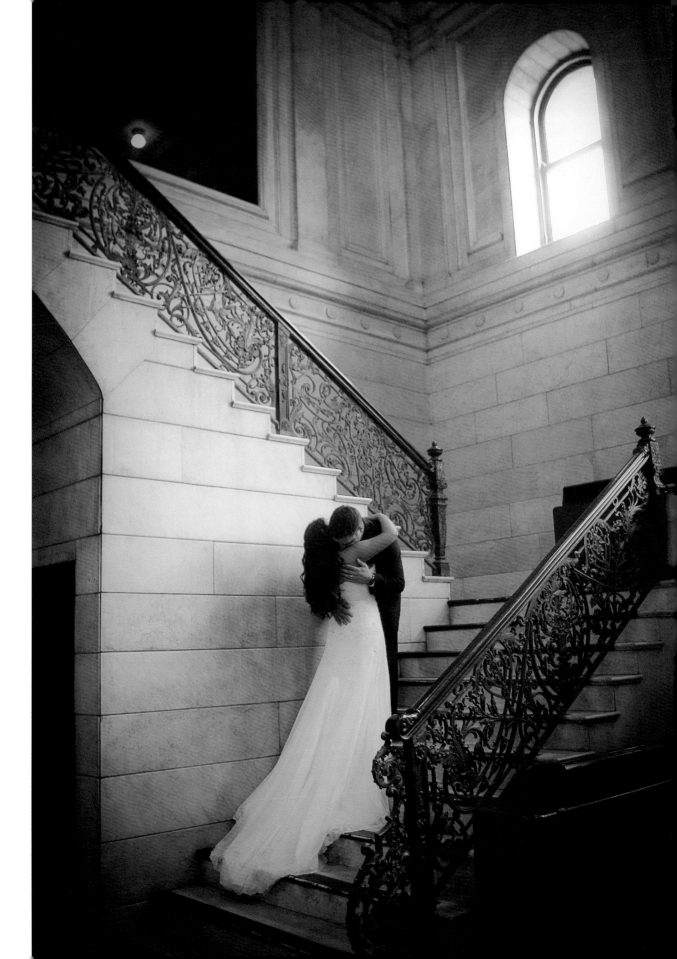

Shoot More

Shooting digitally allows us to take chances. While you should still shoot carefully and aim to get a perfect in-camera capture, there is no reason why you can't also loosen up on the reins and see where your imagination takes you from time to time.

Lenses

To take your photography to the next level, get the best lenses you can and find the most appropriate application for each one. Shoot with natural light as much as possible without sacrificing quality or exposure.

> Get the best lenses you can and find the most appropriate application for each one.

When working in low light, a fast lens (one with a large maximum aperture, e.g., f/1.4) will maximize your shooting options, as you'll be able to collect more light for the exposure,

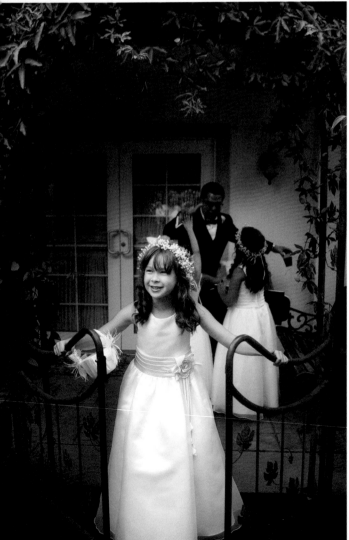

Framing

I often use foreground objects like door frames or other people to add a voyeuristic element to my photography. The more voyeuristic it feels, the more natural the impression you will get from the end result.

Top—Equipment: Canon EOS-1D Mark III with EF 24–70mm f/2.8L IS USM lens. Exposure: f/3.2 at ¹/₆₀ second and ISO 800. Focal length: 25mm.
Bottom—Equipment: Canon EOS-1D Mark III with EF 24–70mm f/2.8L IS USM lens. Exposure: f/2.8 at ¹/₄₀₀ second and ISO 500. Focal length: 24mm.

without adding flash. Other times, an ability to zoom will be more important, so you may be willing to settle for a larger maximum aperture, like f/5.6.

Camera Angles

If you are shooting candidly, you tend to be off to one side and will end up angling the shot. Being off by a few degrees can also offer a creative spin on a more traditional moment. Make sure you keep the important identifying lines straight under most circumstances. Try to angle only where it is appropriate in order to flatter your subject or further enhance the background.

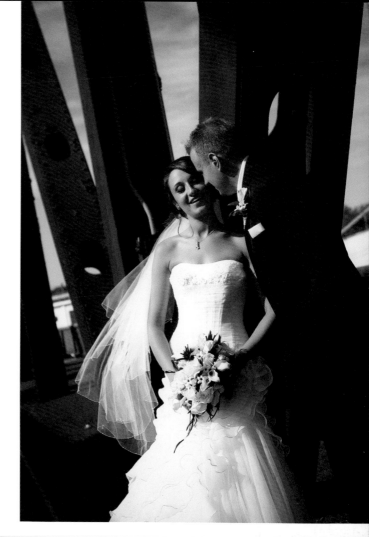

Right—Equipment: Canon EOS-1D Mark III with EF 100mm f/2.8L Macro IS USM lens. Exposure: f/2.8 at ¹/₈₀₀ second and ISO 200. **Below**—Equipment: Canon EOS-1D Mark III with EF 50mm f/1.4L IS USM lens. Exposure: f/2 at ¹/₅₀ second and ISO 250.

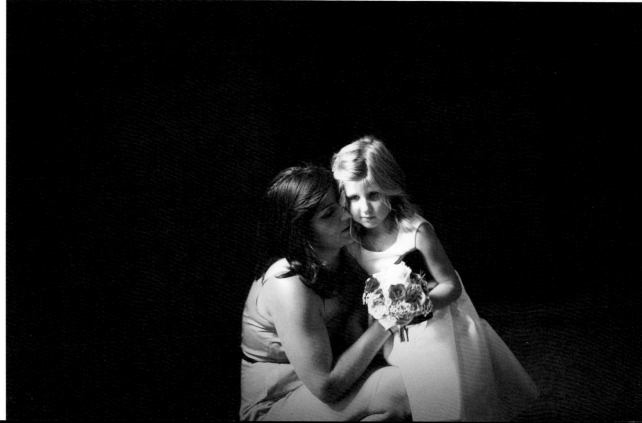

Finishing Touches

Back Up Your Original Files

Nothing is more important to being a profes-
sional than backing up your files. You have an
obligation to provide the service agreed upon
no matter what. So be conscientious about put-
ting your files in two places instead of one after
every wedding. That way, you always have a
copy if anything should go wrong—and eventu-
ally it will.

Software Is an Essential Tool

Whether you're working with Adobe Photoshop
to refine your images or prefer another pro-
gram, there's no denying that postproduction
processing is a critical step in achieving your
creative vision for the final image. Be sure to
do basic retouching (e.g., removing blemishes,
cropping for impact or to eliminate distracting
elements), then play with various filters and

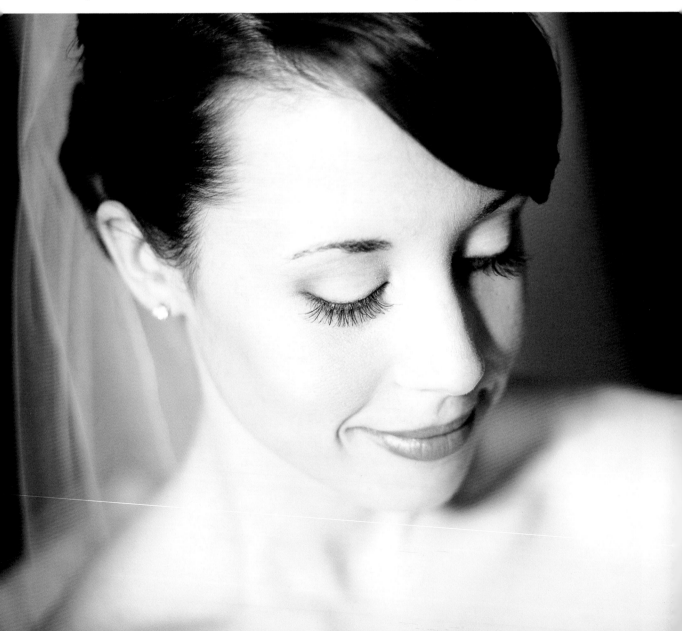

effects. Whether it's simply intensifying the colors in your image or adding a dreamy soft-focus effect or an edgy look, you can really take your images to a new level with a little planning.

Actions

Actions can be a useful, time-saving tool. You can purchase pre-made actions to give your images specific, predetermined special effects or enhancements. Or, you can opt to create your own personal actions. Then you can create a one-of-a-kind enhancement that only you offer, and you can quickly apply it to any image. That will help you to create your own personal brand.

Left—Equipment: Canon EOS-1D Mark III with EF 50mm f/1.4L IS USM lens. Exposure: f/2 at $^1/_{100}$ second and ISO 800. **Right**—Equipment: Canon EOS-1D Mark III with EF 24–70mm f/2.8L IS USM lens. Exposure: f/5 at $^1/_{250}$ second and ISO 800.

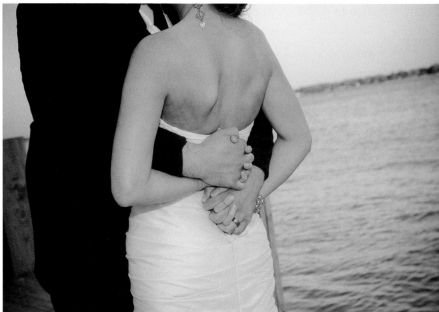

Enhanced Images, Increased Value

Careful image editing and a few special effects can increase the value of your work. You want your customers to be in awe of the final results—images that are perfectly refined to reflect the glamorized version of events that they remember. This means that the effects you use should be realistic . . . but just a little bit better than reality. In most cases, you'll simply want to get rid of extraneous details, enhance colors, and take care that nothing is distracting from your romantic depiction of the day. Aspire to make the image perfect and soft at the same time.

Capture in Color—Then Convert

It is important to photograph the wedding in color, and then do a color-to-black & white conversion if that presentation works for the image. This way, should your clients not seem interested in monotone images, you can offer an alternative. It's important to cover all of your bases.

The Benefits of Black & White

We're in the business of documenting raw emotion and natural moments—and converting a color image to black & white can simplify the photo, drawing attention soley to the subject and story.

At weddings, many guests wear brightly colored, printed dresses. When a woman wearing such a dress appears in a photograph with the bride, the color can be distracting. Doing a

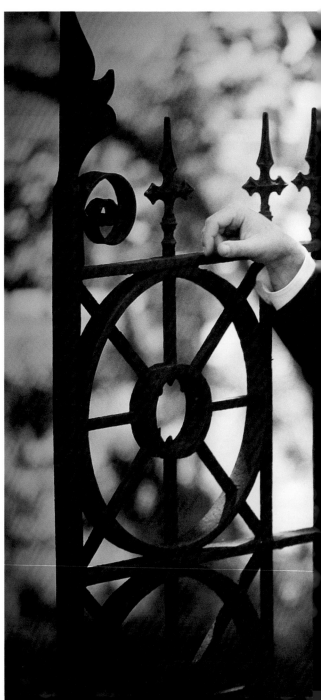

color-to-black & white conversion (or perhaps another tone, if you're feeling there's an artistic benefit for a different look) in postproduction remedies the problem.

By taking the color out of a print, you strip it down to its essential elements. The resulting images have a nostalgic and classic feeling. Brides frequently describe them as timeless.

Left—Equipment: Canon EOS-1D Mark III with EF 24–70mm f/2.8L IS USM lens. Exposure: f/2.8 at $^1/_{200}$ second and ISO 400. Focal length: 24mm. **Below**—Equipment: Canon EOS-1D Mark III with EF 100mm f/2.8L Macro IS USM lens. Exposure: f/2.8 at $^1/_{200}$ second and ISO 100.

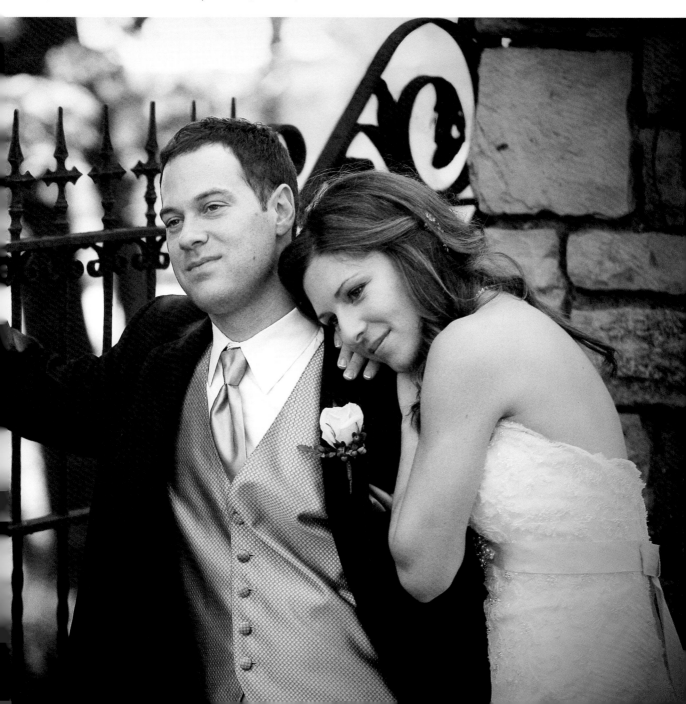

Cropping

Lose Extraneous Details

It is important to crop in the camera as often as possible. However, if you are hurrying to capture a moment and you abandon your cropping principles in order to catch it, you can fix it after the fact. Any image-editing software can aid you in this endeavor.

> A successful image is often all about gestures and expression, so crop to preserve and enhance those elements.

Make sure to crop in the way that best services the story you are trying to tell. For example, crop out the people in the background having an unrelated conversation, but save the part where the bride and groom are holding hands. A successful image is often all about gestures and expressions, so crop to preserve and enhance those elements of the photograph. You may find that your cropping will result in a photo with a nontraditional aspect ratio—like a square or a long, narrow panoramic shape—and that's perfectly fine. You can mat the image to fit a traditional frame size.

Below—Equipment: Canon EOS-1D Mark III with EF 24–70mm f/2.8L IS USM lens. Exposure: f/2.8 at $^1/_{50}$ second and ISO 160. Focal length: 48mm. **Facing page**—Equipment: Canon EOS-1D Mark III with EF 100mm f/2.8L Macro IS USM lens. Exposure: f/2.8 at $^1/_{4000}$ second and ISO 250.

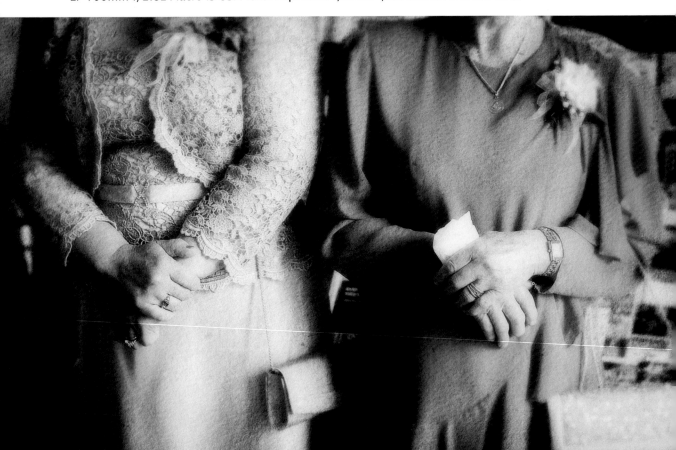

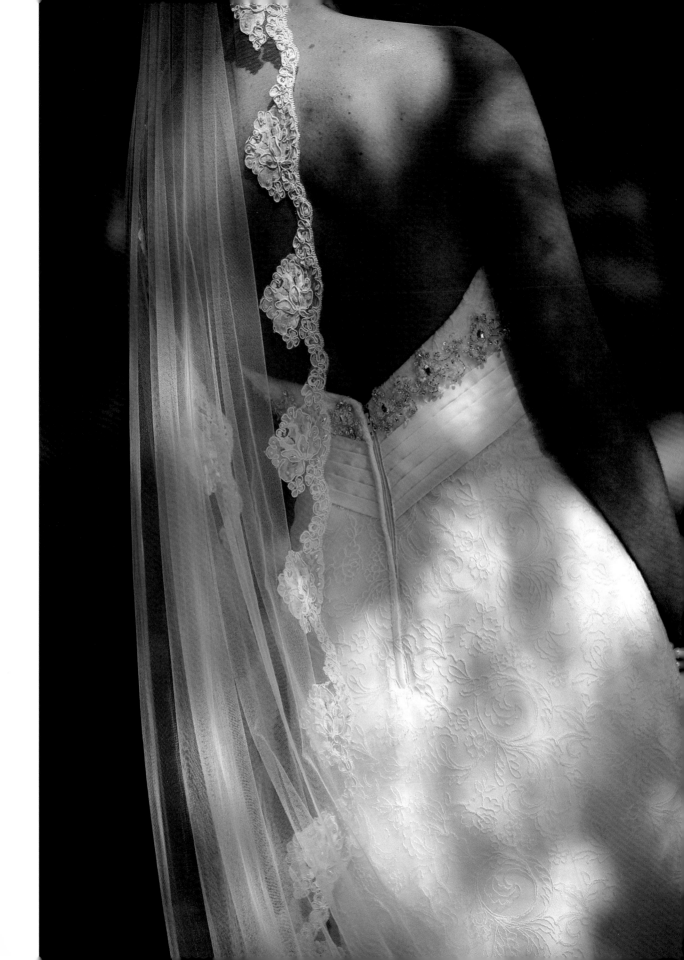

Special Effects

Image-editing software can allow you to enhance your digital photos so that they show your personal style. Allow your "look" to develop. Try to identify specific qualities and/or effects in order to develop a signature style—a look that you will later be known by. This

Left—Equipment: Canon EOS-1D Mark III with EF 50mm f/1.4L IS USM lens. Exposure: f/2 at $^1/_{1250}$ second and ISO 1000. **Facing page**—Equipment: Canon EOS-1D Mark III with EF 100mm f/2.8L IS USM lens. Exposure: f/2.8 at $^1/_{640}$ second and ISO 320.

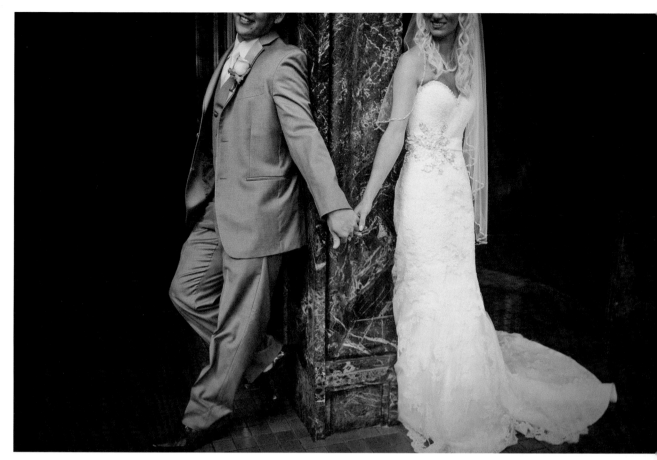

allows people to identify your work and gives it a unique voice. For example, you can try muting the colors in your prints or enhancing them. You could add a vignette, a blue tone, or a sepia tone. There are no set guidelines in this area because the style you develop has to be uniquely your own. It must be original.

When developing your own personal style of photography, bear in mind that you are working on wedding photos. Most of them will need to have a romantic vibe. You can throw in a few experimental shots at each wedding, but the bulk of your images must be romantic and standard enough to fulfill the family's expectations. The selected "unusual" pictures then look even more interesting and exciting by comparison.

Go On, Experiment!

Experimenting with postproduction techniques will lead you down paths you hadn't considered. You will be able to come up with interesting artistic effects to enhance your images. Just start trying things out to see what fits the best. Artistic techniques can reveal themselves in the stylization, cropping, and story of your work.

Always establish a strong mood and point of view. If the photograph demands cool coloring and contrast in the details, make sure to attend to that. If the mood strikes you as quiet, give your image the appropriate coloring to make that point. Try to make your work realistic yet romantic. You want the bride to remember things the way they were—but maybe just a little bit better!

Fine Art 1

If you want your work to transcend the idea of a "candid" shot, you need to treat each print individually as a work of art. There are a variety of ways to do this, but always bear in mind that the piece needs to be polished and strong with a clear meaning. Choose photos that have the specific qualities that you are looking for, then filter them, frame them, or print them in a thoughtful manner.

To complete a piece successfully, think creatively and artistically. Don't just frame a piece, finish it. Does the photograph warrant being printed on canvas? Should it be printed really large, on a huge board or plaque? Should it be printed very small? Does it warrant a gallery mat or perhaps a huge white border? The subject matter should guide your answers to these questions.

The Finishing Touch

Try unique printing services like watercolor or fine-art papers. They produce an extreme matte finish, but with texture. When warranted, this type of printing can add depth and intrigue to your work.

Below—Equipment: Canon EOS-1D Mark III with EF 24–70mm f/2.8L IS USM lens. Exposure: f/2.8 at $^1/_{1000}$ second and ISO 400. **Facing page**—Equipment: Canon EOS-1D Mark III with EF 24–70mm f/2.8L IS USM lens. Exposure: f/2.0 at $^1/_{250}$ second and ISO 1600. Focal length: 24mm.

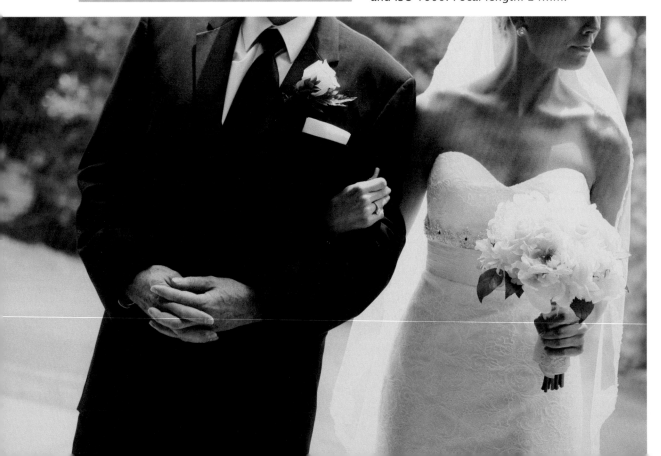

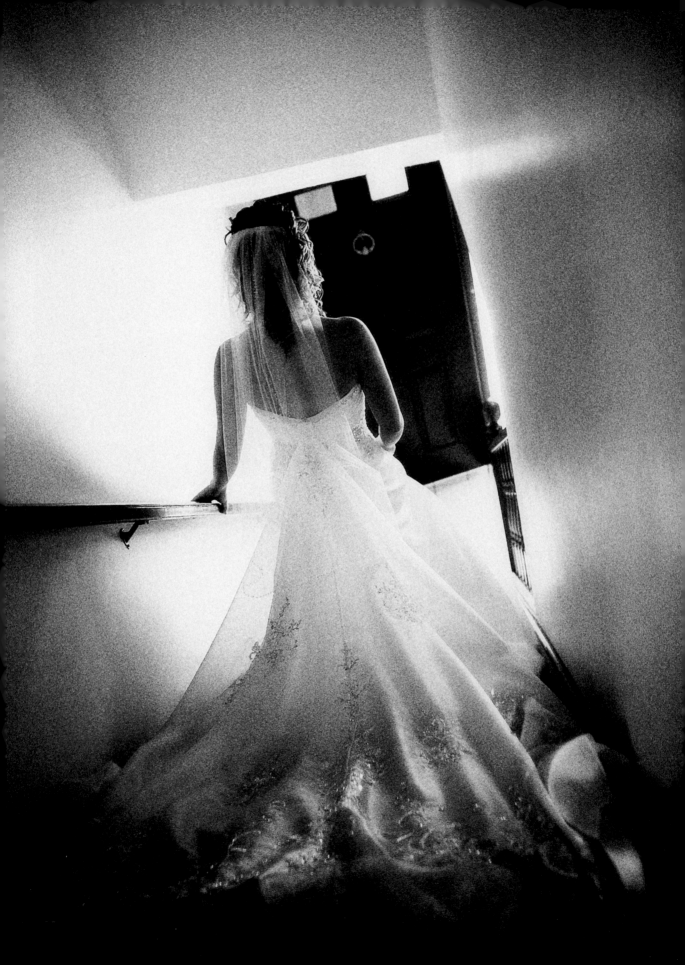

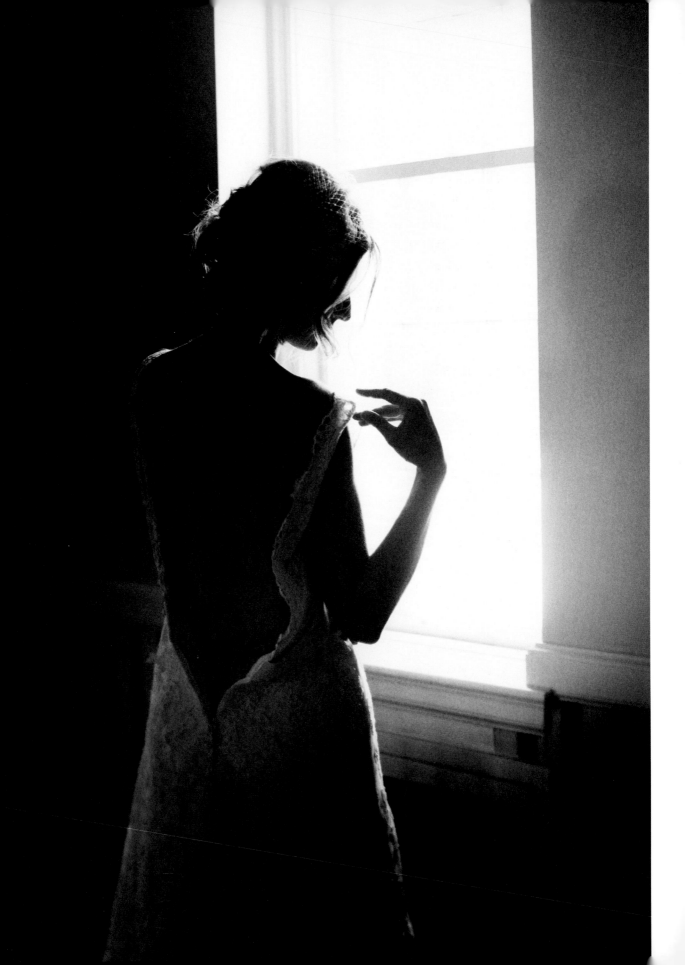

Choosing Products

When getting started, the only way to find out what products will work best with your images is to try them. In my experience, it's also the only way to push your craft further into places you never thought it could go. You will find that you surprise yourself. Allow yourself to explore any option available to you in order to create new moods and effects. However, use discretion! You want to highlight your image, not detract from it.

The finished image is all about the mood it presents and the feelings it evokes in the viewer. A moody image might require a dark mat and huge, deep frame. Conversely, a ridiculously cute little girl making a funny face might be printed small with a broad white mat or a pink mat to draw you in. If you find yourself with a series of pictures, think about the best way to display them together. Don't forget coloring and treatment when editing. If you are printing for a specific colored frame or mat, you need to make sure that they will complement each other.

Any special effect that you play with can lead you in a new direction. Explore your options and keep an open mind. Get customer feedback to see if you are heading in the right direction.

Get Creative!

The more you can tap into your creative side, the easier this process will be. You are trying to advance beyond traditional photojournalism, and that will require you to think outside the box. Succeeding will require immense discipline on your part to continually try new things and experiment with new technologies. Don't dismiss something without giving it proper attention first. A by-product of constantly being creative and trying new things—even if you ultimately discard them when they don't work—is that you are constantly training yourself and gaining more and more experience. That is invaluable. Embrace your creative side and don't be shy, even if it feels silly. Constantly try something new. If you keep pushing yourself in this way, you won't be dissatisfied.

Facing page—Equipment: Canon EOS-1D Mark III with EF 50mm f/1.4L IS USM lens. Exposure: f/2.2 at $1/400$ second and ISO 800. **Below**—Equipment: Canon EOS-1D Mark III with EF 24–70mm f/2.8L IS USM lens. Exposure: f/2.8 at $1/800$ second and ISO 160. Focal length: 34mm.

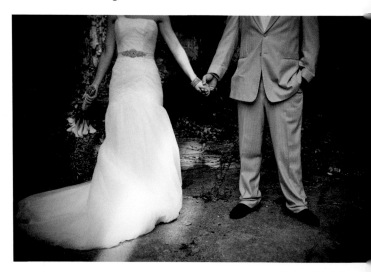

Push Your Boundaries

The only way to develop a unique style in your photography is to experiment. Your more artistic images will add a welcome change to the overall proof book that you provide to clients.

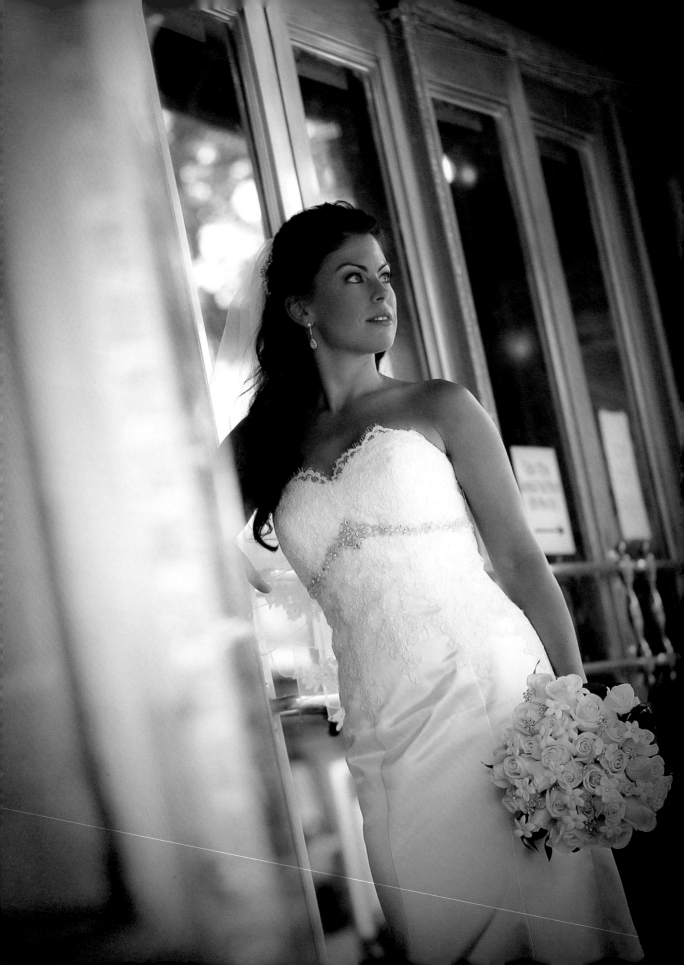

Proofs Presentation 48

Efficiency

Whether you handle your proofs presentation in person in your studio or prefer the convenience of presenting your images online, you should provide your clients with the opportunity to view and order their beautiful, polished images while they are still reeling from the bliss of the wedding. When emotions are high, sales are bigger.

Present Polished Photographs

The world of digital photography allows us to shoot wildly and without restraint, but that should not mean that we don't edit our results. If you provide your customers with digital proofs, you need to take the same care in editing that you would to present a print. Whether they view their proofs on a computer screen or in an album, your sales will be based on your customers' responses to your work. If you give them a lot of untouched, disorganized files that are not color- or exposure-corrected, they are not likely to order much (or have the confidence in you to book future sessions). It is also not likely that they will give you glowing referrals, which can cost you business.

Edit down your photos for impact and identifiable individualization—you want works of art, not just pleasant candids. If you offer your clients ten similar photos, they will not have the

Bring Your "A" Game

Show your client only the best version of the photo. When you avoid presenting a series of similar images, the selection process is easier for your clients and the demand is higher.

same impact that one profound photo would. Let them see one finished, polished version of the photo you've chosen—a singular photo that freezes an exceptional moment. It will not compete for attention with any similar moments or have any trouble standing out. Also, choose your proofs carefully so that they tell the full story without omitting any parts of the day.

Choose your proofs carefully so that they tell the full story without omitting any parts of the day.

Exercise the same care in digital proof production as you would with prints. Make your work stand out and look like it's worth a lot. Photography sales are all about perceived value; the image must seem worthy of its price. Furthermore, throughout the proofs, your style and skill should be evident. It is very easy to forget these principles when working with digital proofs.

Facing page—Equipment: Canon EOS-1D Mark III with EF 100mm f/2.8L Macro IS USM lens. Exposure: f/2.8 at $1/60$ second and ISO 200.

| # Expanding Your Reach

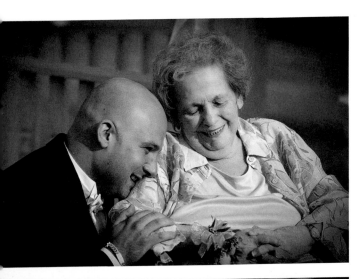

Friends and Family

Many photographers now sell their images on-line. They benefit from sharing the instructions (and password if necessary) with the wedding guests utilizing event cards or e-mail. Doing so ensures a larger pool of prospective customers and bigger sales.

Parents of the bride and groom tend to have more disposable income than most young couples, and they may be interested in ordering prints or a parents' album filled with beautiful images of memorable moments. Also, members of the extended family, attendants, and guests who make an appearance in your images may be interested in purchasing some of your prints.

Word-of-mouth referrals are a great way to ensure your future business success.

Future Clients

Word-of-mouth referrals are a great way to ensure your future business success. By exposing a wider audience to your artistic vision and your professionalism, you'll likely find that your happy clients will point those in need of wedding coverage your way.

Top—Equipment: Canon EOS-1D Mark III with EF 100mm f/2.8L Macro IS USM lens. Exposure: f/2.8 at $^1/_{5000}$ second and ISO 320. **Bottom**—Equipment: Canon EOS-1D Mark III with EF 100mm f/2.8L Macro IS USM lens. Exposure: f/2.8 at $^1/_{500}$ second and ISO 400. Focal length: 95mm. **Facing page**—Equipment: Canon EOS-7D with EF 100mm f/2.8L Macro IS USM lens. Exposure: f/5.6 at $^1/_{200}$ second and ISO 320.

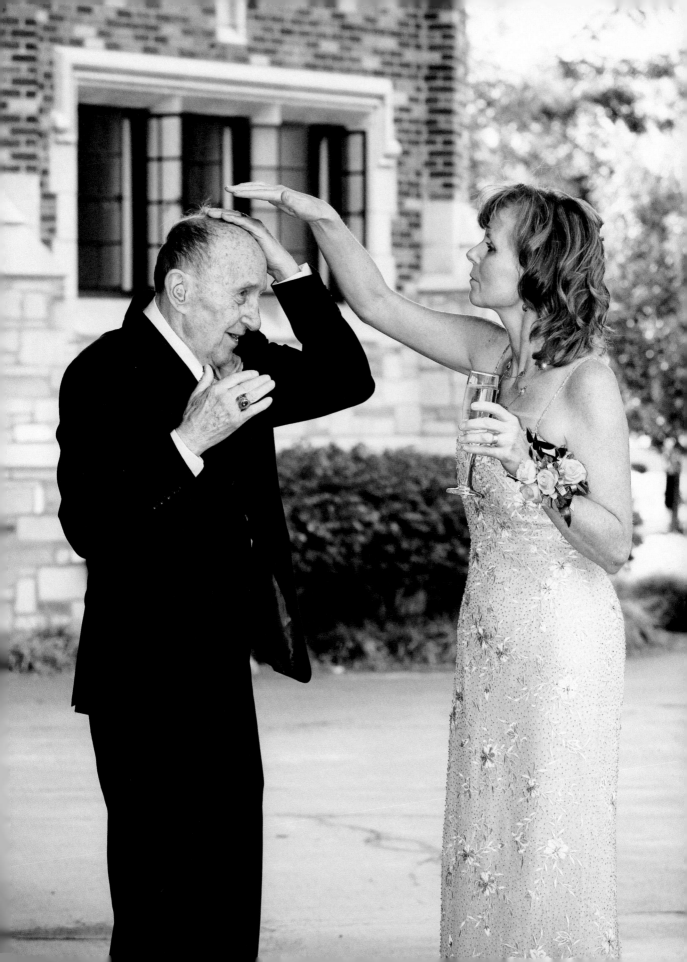

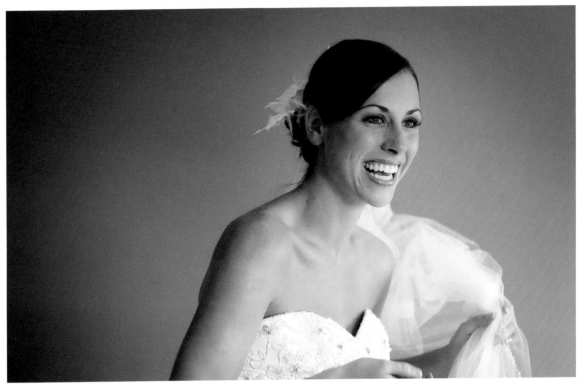

Above—Equipment: Canon EOS-1D Mark III with EF 50mm f/1.4L IS USM lens. Exposure: f/2 at $^1/_{60}$ second and ISO 640. **Facing page**—Equipment: Canon EOS-1D Mark III with EF 24–70mm f/2.8L IS USM lens. Exposure: f/2.8 at $^1/_{1250}$ second and ISO 250. Focal length: 57mm.

Sales are all about making the client feel happy and comfortable. Brides can't wait to see their photos, but they often have a lot of fears and anxieties about the process too—they want everything to be just right.

Comfort

Your presentation and timeliness are instrumental in making sure the bride is thrilled with her final product. Make sure that you always take the greatest care with your work in order to ensure that she will like what she sees.

Enthusiasm

Consider offering previews or sneak peeks of the wedding images in order to raise the excitement level for the bride and groom, as well as their friends and family. If your clients have a longer wait, a sneak peek will help quell their eager anticipation and give them something to share, which will generate word-of-mouth advertising for you.

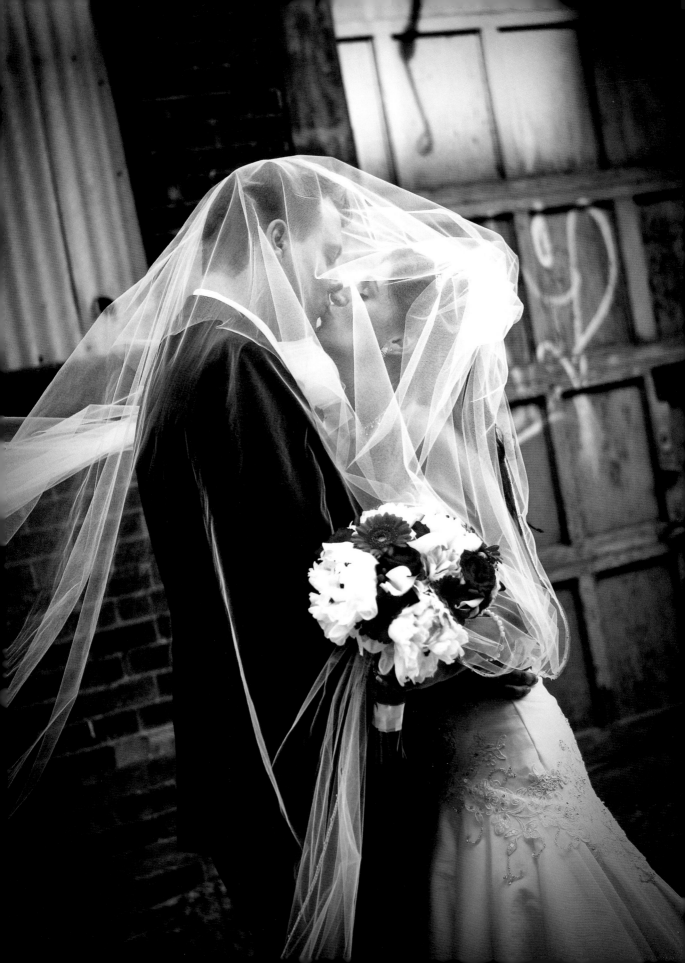

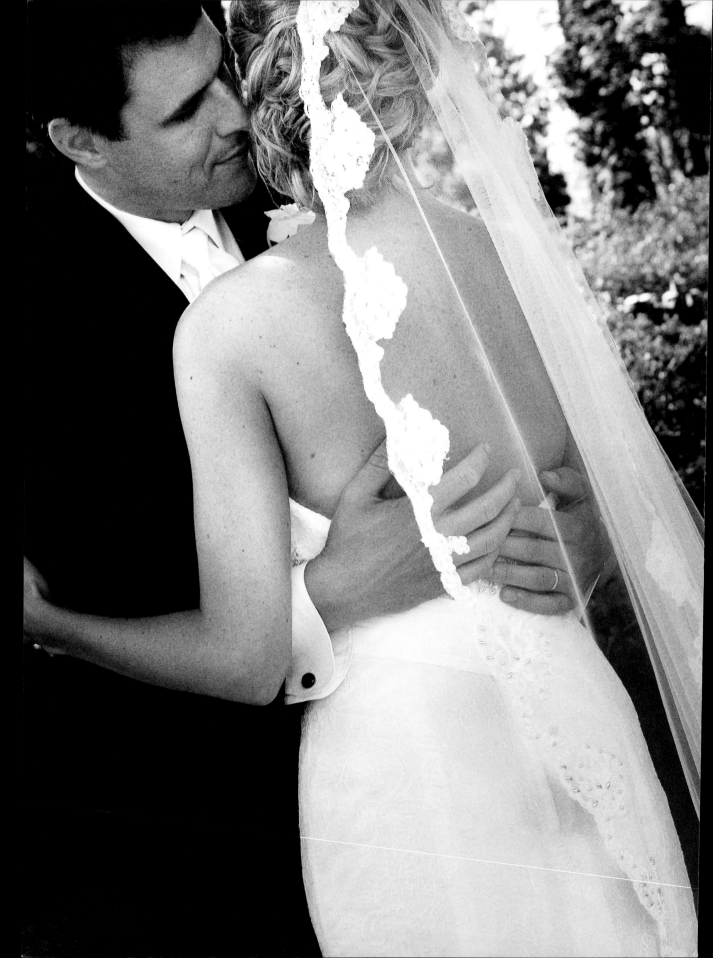

Facing page—Equipment: Canon EOS-1D Mark III with EF 24–70mm f/2.8L IS USM lens. Exposure: f/5.6 at $^1/_{200}$ second and ISO 250. **Right**—Equipment: Canon EOS-5D Mark III with EF 50mm f/1.4L IS USM lens. Exposure: f/2.2 at $^1/_{250}$ second and ISO 800. Focal length: 95mm.

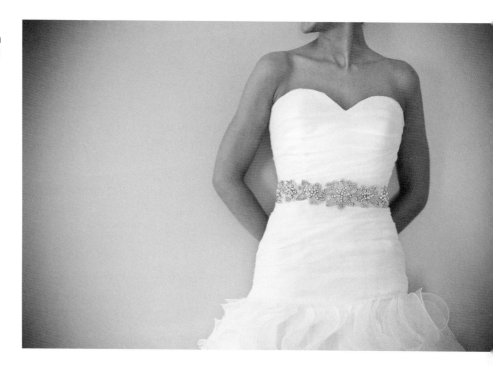

Gallery-Inspired Presentation

In order to inspire in your customers the impression that your work is art, you will want to make sure you are in the right ballpark. Try visiting a local art gallery to get inspiration. Notice the treatment of the photographic images and paintings. Present your images in the same manner, both in terms of the image design and the lighting strategies used to accentuate them. Put on a show. The drama created by doing this will only add to the impact of your images—and your clients' perception of their worth.

Appropriate Pricing

The thought, care, and treatment that go into each image need to be reflected in your pricing. Good art is not cheap. Setting your prices too low will make your work seem worthless. On the other hand, you mustn't set your prices so high (for your community) that your images are unaffordable and never make it to a living room. Find a balance, but make sure the price accounts for the difference between any old picture and a work of art.

Having these fine-art pieces on display in your studio will give your clients inspiration for their own wedding photos. They will see the displays and imagine what they can do with the photos they've purchased.

Get Inspired

Images printed on stretched canvas and artfully displayed on your walls can go a long way in creating a gallery feel in your studio. These polished, high-impact displays will help your clients appreciate the costs associated with your work.

A Cohesive Look

Documentary wedding images are all captured at a single event, but they vary quite a bit from one shot to the next. Of course, they are also integrated with each other. For this reason, these images lend themselves best to presentation in an album.

Options

There are beautiful books available for all budgets and tastes. You can help your customers choose the right photos to fill a book and assist them in determining the best position for each shot to ensure maximum impact.

Digital albums (a flush-mounted album with a layered picture style) are in high demand. They provide the modern feel your clients are asking for and provide a fresh alternative to a traditional piece. If you are doing your own layouts, try grouping your photos by subject and mood to strengthen the presentation.

Software and Design Templates

When you begin your venture into flush-mounted albums, you must first decide whether you want to tackle your own layouts or send the images to a professional designer. There are many software options available with pre-made

Album design is time-consuming. When you are getting started, it's wise to consider whether you want to use a template to design albums that suit your vision or outsource to a professional designer.

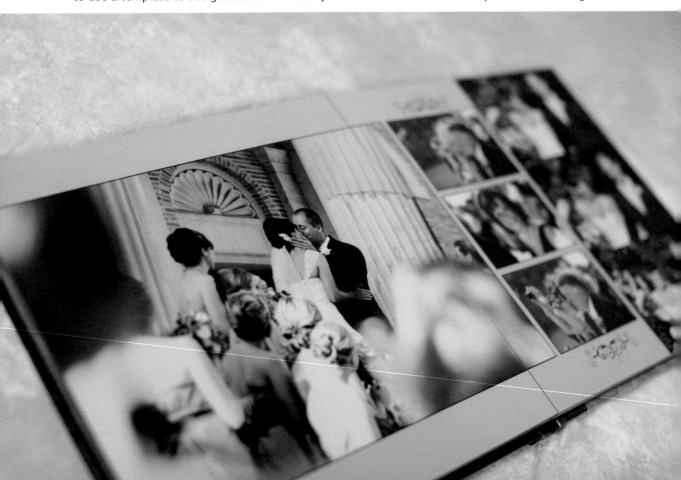

Be sure that your albums are printed on high-quality, archival materials.

templates that you can use as-is, or customize to fit your needs. On the flip side, album design is very time consuming, so you may benefit from sending your materials to a professional company. They will prepare your design and allow you to approve the proof before it goes to print. You must also decide where you will have your final albums printed. Be sure the company utilizes archival, high-quality materials.

Storytelling

When designing an album, you want to avoid a cluttered appearance. If you offer only one version of each shot and it looks great, there are fewer options for the client, leaving you with a smaller, more manageable selection of great images that can be laid out in a more graphically pleasing way.

> Use the detail shots
> you created throughout the day
> to provide a break between pages.

Transitional Shots

Use the detail shots you created throughout the day to provide a break between album sections or fill in a bland background.

53 Prints and Other Products

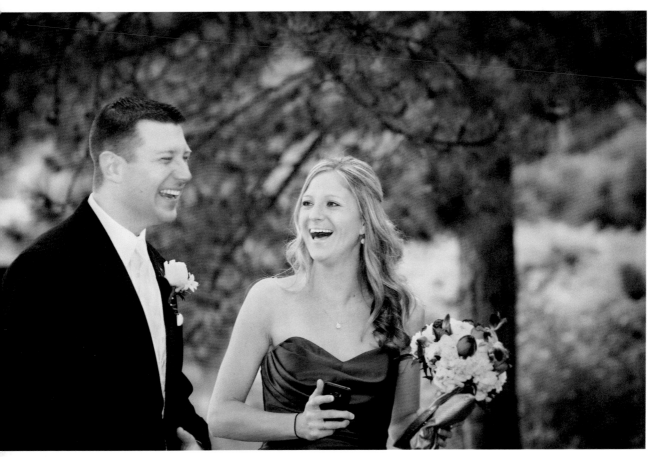

Equipment: Canon EOS-5D Mark III with EF 70–200mm f/2.8L IS USM lens. Exposure: f/5.6 at $^1/_{160}$ second and ISO 800.

Wall Prints

Selling big prints can yield big profits. They are even more important to today's photography sales since more customers are receiving the digital copyrights to their images. This means they can print all of the small images that they want at home or at any printer of their choosing. The things that they will turn to a professional photography studio for are large prints, frames, and canvases. These types of sales are a big commitment for the customer, and they want them done right. You can provide your expertise and final editing skills in order to ensure that your client's final product is outstanding. That's something the bride and groom can't get

> You can provide your expertise and editing skills to ensure that your client's final product is outstanding.

at a big discount store or via a consumer-oriented online printer.

Frames

Offering frames as an add-on to prints is a great way to increase your sales. Since basic frames are so easy to purchase, try to offer full customization or unique frames that your customer can't price shop for elsewhere. They will beautifully complement a large print, and the customer will be able to bring home a finished piece of art.

Alternative Products

Beyond framing, consider alternatives such as canvases, photo gifts, or illuminated frames. A big part of the service you offer will be based on your expert opinion. Your customers will be purchasing through you because they want your help. They need to be shown what to do with something unique. Offering these options can greatly benefit your sales.

Offer Your Expertise

Providing customers with your expertise and knowledge will improve your sales. Show them examples of gallery-style matting and framing or canvases so that they are aware of the options available to them.

Left—Equipment: Canon EOS-5D Mark III with EF 50mm f/1.4L IS USM lens. Exposure: f/2.0 at $^1/_{100}$ second and ISO 800. **Right**—Equipment: Canon EOS-5D Mark III with EF 70–200mm f/2.8L IS USM lens. Exposure: f/5.6 at $^1/_{160}$ second and ISO 800.

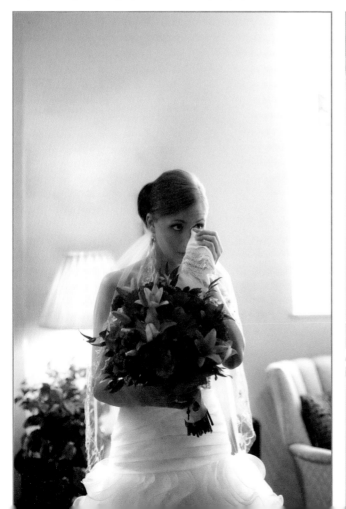

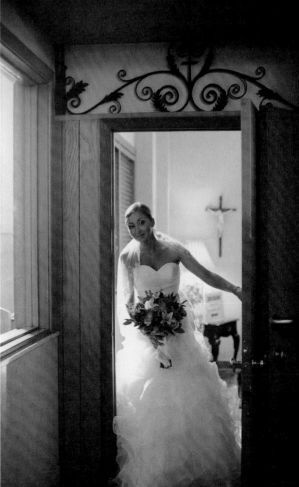

Build a Lasting Relationship

After the wedding is over and the bride has received her album, don't let the relationship dwindle. In the wedding business, you have a unique opportunity to get to know the bride and her whole family. You get a chance to form a relationship with them and have them get to know you and your style quite intimately. You can use that relationship to your sales advantage.

Make sure that they know you personally and they bond with you. If they like you, they will remember you. If they remember you, they will refer others and likely use you again for portraits in the future.

Also, keep in mind that the principles of photojournalism can be applied to other genres of photography very effectively. Let your customers know that your services are available for portraiture after the wedding. The bride and groom may already have children—or may be starting a family in the near future. It's not too early to give them the idea to come back or refer others to do the same.

Advertise the post-wedding services you offer to them and keep in contact. You want them to feel as if, on their wedding day, you became an honorary member of the family. If you can do that, you'll be first in their mind when it comes to photos in the future.

Below—Equipment: Canon EOS-5D Mark III with EF 70–200mm f/2.8L IS USM lens. Exposure: f/2.8 at $^1/_{1600}$ second and ISO 800. **Facing page**—Equipment: Canon EOS-1D Mark III with EF 50mm f/1.4L IS USM lens. Exposure: f/2.2 at $^1/_{60}$ second and ISO 800.

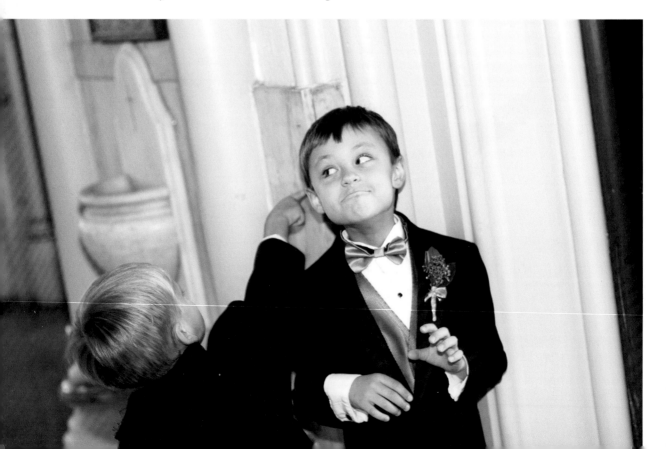

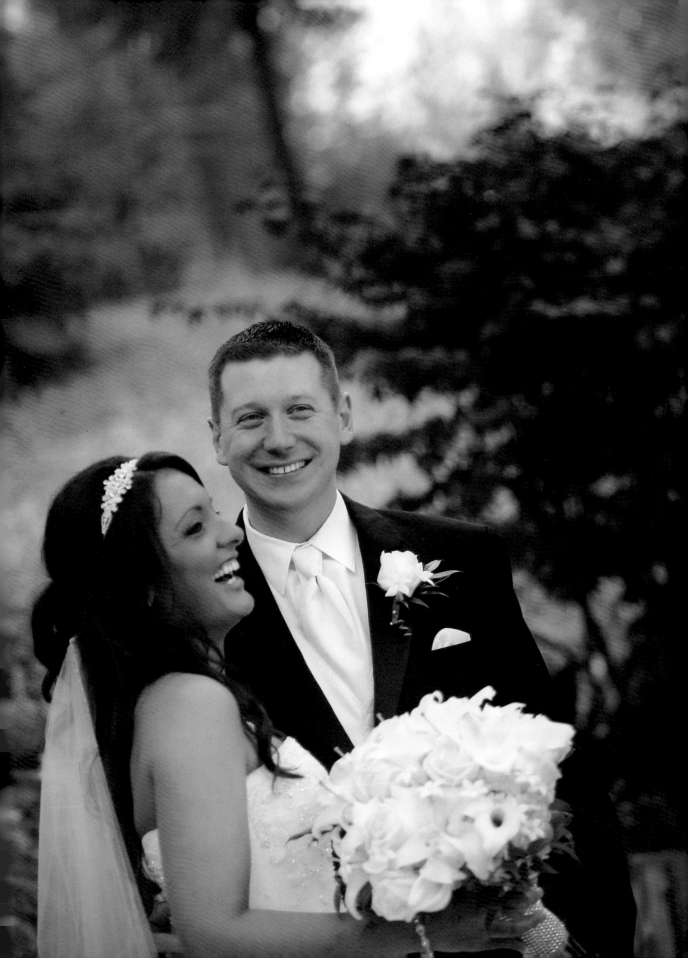

55 | Expanding Your Business Focus

We have spent the majority of the book mastering the concepts of the decisive moment and educated instinct, opening up our minds to the possibility of self-projection into a situation. We have a firm understanding of the verbal and physical cues that help us define moments, and we know how to both anticipate and react to them. We understand the roles of both genuine moments and natural setups. Now that you know how to tackle a wedding in an instinctive photojournalistic style, I'd like to show you how to make these skills do double duty by applying them to photographing children.

Shared Characteristics

From a photojournalistic standpoint, children and weddings are very similar subjects. Both involve a great deal of action, and in order to photograph them well, you need to avoid interacting with the subjects. The subjects must be able to relax and be themselves. There will be tons of activity, and it's up to you to sort through the multitude of moments to find exactly the right ones.

All of the preparatory actions you took at a wedding apply here. Your camera needs to be ready at any moment, pre-focused whenever possible, and preferably armed with a long

Equipment: Canon EOS-1D Mark III with EF 70–200mm f/2.8L IS USM lens. Exposure: f/3.5 at $^{1}/_{250}$ second and ISO 400.

Left—Equipment: Canon EOS-1D Mark III with EF 100mm f/2.8L Macro IS USM lens. Exposure: f/3.2 at ¹/₂₅₀ second and ISO 200. **Right**—Equipment: Canon EOS-1D Mark III with EF 70–200mm f/2.8L IS USM lens. Exposure: f/5.6 at ¹/₁₀₀ second and ISO 200. Focal length: 135mm.

zoom lens to allow for distance and privacy. Preparative thinking is an absolute necessity in these situations. Kids, unlike adults, do not care one bit about what you're trying to accomplish—in fact, if they display much interest in what you're doing, then you're likely attacking the situation incorrectly. In order for you to photograph authentic moments, the subjects need to be virtually unaware of you. They need to be free to express themselves normally.

Intense Emotion

Children are immensely more emotional and acutely more aware of the world than adults. Therefore, photographing children in an emotional way is perhaps the most fitting approach to capturing their joy and mystification. Look for the emotional highs to present themselves. You are not just looking for a smile, or even for them to face you. You are recording joy, wonder, and intrigue—straight, raw emotion in action. Your goal is to capture a moment so charged with impact and resonance that it takes the viewer back to his or her own childhood.

Real Impact

Keep an eye out for behavior that signifies childhood—or, more specifically, behavior that showcases the personality of the child you're photographing.

Managing Distractions

Before you can begin to shoot, children need to be secure with their surroundings and engaged in some sort of activity. The activity will attract their attention and provoke the kind of playful reaction you're looking for. I find that the use of toys and games gives me the freedom to both distract and entertain my young subjects. A playground makes a useful background and provides them with many different kinds of stimuli.

Parents know what evokes responses from their kids, so it's only logical to put them to work in this process.

Having a parent present is also a very helpful buffer. The child will look for and talk to the parent, and the parent can, in turn, encourage the play and nudge them back into the right area whenever necessary. Additionally, parents know what evokes responses from their kids, so it's only logical to put them to work in this process. Invite them to be engaged in the playtime, and explain your process to them so that they can help direct the action.

With the parent involved, you shouldn't have to do any talking. The conversations should be between the parent and child, leaving you to simply observe, and allowing the child to forget your presence a little more. Think of it as witnessing a daily playtime. You are the onlooker, privy to a personal and intimate time. Capturing it in this way will bring home the kinds of images that really portray childhood for this family. Each family is unique, and this individualized, unscripted method will allow them to simply be themselves.

Below—Equipment: Canon EOS-1D Mark III with EF 70–200mm f/2.8L IS USM lens. Exposure: f/5.0 at $^1/_{320}$ second and ISO 400. **Facing page**—Equipment: Canon EOS-5D Mark III with EF 70–200mm f/2.8L IS USM lens. Exposure: f/2.8 at $^1/_{500}$ second and ISO 250.

Parent-and-Child Interactions

To enhance your children's photography experience, key in to the interaction between a parent and child or the child and his or her siblings. Photographing moments of interaction between parents and their kids can result in some of the most beautiful and simplistic images you'll ever take. The unconditional love that you capture in a look or gesture is timeless. Similarly, every parent wants to see their children happily involved with one another, getting along and sharing their learning experiences. They will be grateful to you for documenting these moments.

Working Outdoors Is a Must

When shooting in a studio, you are confined by the size of your backdrop and the position of your lights. If you are trying for a candid portrait, you can't afford to have those restraints. The children must be able to move around and play. You will need natural backgrounds so that you are free to move about too.

Shooting at a local playground is ideal. It provides you with the needed space, amusement, and distraction for your young subjects.

Fill Flash

I have found that a fill flash is often a very useful asset when shooting photojournalistic portraits. This is because you must capture the action wherever it happens, you won't be able to control the circumstances, and the lighting is almost always less than ideal. A fill flash can light up the subject's face, giving life to the eyes and correcting some exposures. It can also help dampen a bright background, bringing the focus back to the subject's face.

Equipment: Canon EOS-1D Mark III with EF 70–200mm f/2.8L IS USM lens. Exposure: f/5.6 at $^1/_{200}$ second and ISO 100. Focal length: 78mm.

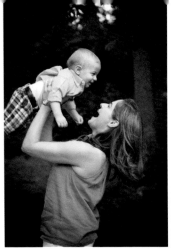

Right—Equipment: Canon EOS-1D Mark III with EF 100mm f/2.8L Macro IS USM lens. Exposure: f/3.2 at $^1/_{160}$ second and ISO 200. **Far right**—Equipment: Canon EOS-1D Mark III with EF 70–200mm f/2.8L IS USM lens. Exposure: f/5.6 at $^1/_{200}$ second and ISO 400. Focal length: 105mm.

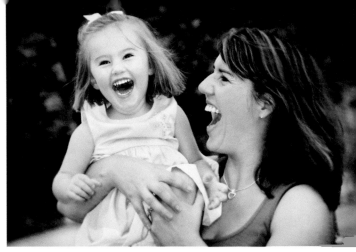

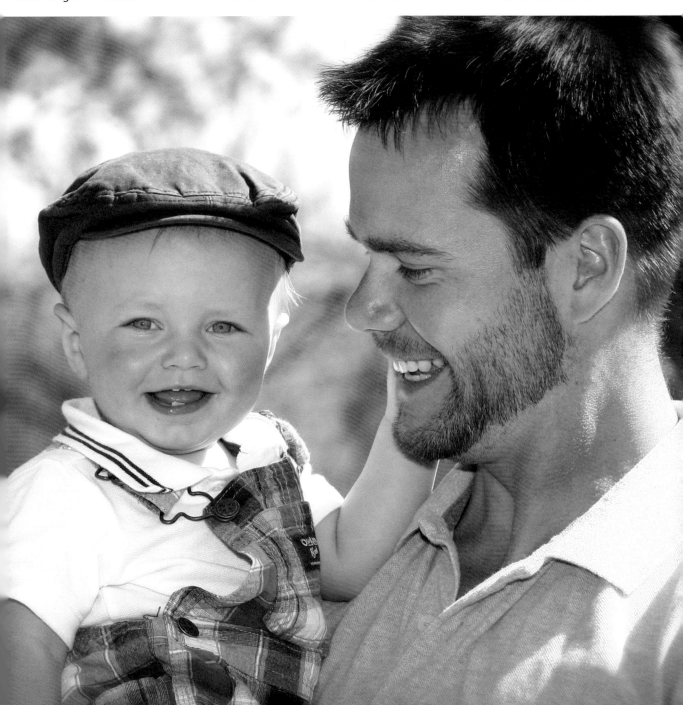

In much the same vein as the natural setups we can use in wedding photojournalism, in children's portraiture, you, the parent, or the child can help stimulate the action in these photographs—then leave it free to develop as it needs

If playtime takes a downturn and high emotion turns to melancholy, your job is not necessarily over.

to. This could be as simple as arranging to take the photos at a park, where you'll have access to slides, sandboxes, swings, flowers—anything they might enjoy. It will not only encourage

play, and playful expressions, it will also lengthen the shoot and make it more enjoyable for the children. If they're having fun, they're likely to become repeat customers.

Push Through

If playtime takes a downturn and high emotion turns to melancholy, your job is not necessarily over. Keep shooting, because you may be surprised by the result. A child quickly progresses from happiness to sadness, then right back to happiness. During this time, they are considering what upset them and evaluating the situation. After the meltdown, they may be subdued

Left—Equipment: Canon EOS-1D Mark III with EF 70–200mm f/2.8L IS USM lens. Exposure: f/2.8 at $^1/_{400}$ second and ISO 400. Focal length: 125mm. **Right**—Equipment: Canon EOS-1D Mark III with EF 70–200mm f/2.8L IS USM lens. Exposure: f/3.5 at $^1/_{320}$ second and ISO 400. Focal length: 200mm.

Equipment: Canon EOS-1D Mark III with EF 50mm f/1.4L IS USM lens. Exposure: f/2.0 at $^{1}/_{1250}$ second and ISO 400.

and thoughtful. Children are all different, but each of them will probably show you a range of emotions. Be ready to accept the good, the bad, and the melancholy. There just may be more emotion in a quiet moment than there is in a joyful one.

> There just may be more emotion in a quiet moment than there is in a joyful one.

Adding Props

A playground is the ideal choice for children old enough to participate. But if you don't have access to a playground (or it isn't photogenic), or if your subject is too young to use it safely,

then you will want to think about incorporating toys and props into your shoot. You can choose to provide them yourself or ask the parents to bring the child's favorite toys. Balls, wagons, and kites are all good examples of toys that can function as props without becoming distractions. Bubbles and their favorite baby dolls are also great choices. Selecting a favorite toy also helps memorialize that phase of their life in their portraits and may really appeal to the parents. It is a happy memory that you can incorporate. Always keep an eye out for photographic prop ideas that can inspire action, and be sure to consult with the parents every step of the way.

Selling Children's Portraits

Customer Service and Sales

Just as a modern bride is looking for a personalized product, so are moms. Mothers will be touched and overwhelmed by photos that show their child's true personality. Photos that touch them will be perceived as both timeless and priceless. If you can break out of the box of traditional children's photography, and do it with elegance and a polished finesse, your products should sell themselves to a happy mom.

If you remember to shoot for moments with emotional resonance, you will more easily connect with your clients and viewers: Mom (or Dad!). To increase her desire, you need to create work that she will connect with. For you, desire means more products sold.

> A client won't know what is available to buy or have a desire for a product unless you show it to them.

Remind yourself of all of the extra attention you provided to your bride. You worked with her to find the perfect album that fit her budget and personality. You discussed the type of work you shoot and the process by which you do it. She knew up front what you needed from her and what she would receive from you. Apply all of this knowledge to your new client. Mom will want an album, but what kind? What type of shoot is she interested in? Does she fully understand the photojournalistic style? Is she interested in artistic close-ups or an unusual presentation of prints?

You can also increase your sales to moms and dads in many of the same ways that you did for weddings. A client won't know what options are available or have a desire for a product unless you have an example to show them. Photo jewelry or pocket-sized albums are wonderful opportunities for parents and grandparents to show off the portraits with pride. These are excellent add-ons for any sale. Consider what types of small albums fit the budget of most families in your market and then provide a good selection. Look for any other personalized photo item that can complement your studio's aesthetic.

Special Touches

Think of ways to make each portrait session a unique experience. Remember the mom's name and her son or daughter's name. Provide a thank-you card or specialized packaging upon pickup. Check in with your clients often and establish a great relationship.

Facing page—Equipment: Canon EOS-1D Mark III with EF 70–200mm f/2.8L IS USM lens. Exposure: f/2.8 at $^1/_{400}$ second and ISO 400.

CONCLUSION

Modern wedding photography is an increasingly competitive marketplace. The low costs of digital photography and dropping equipment prices are keeping competition fierce. Your business' potential is dependent on your willingness to go the extra mile and tackle new styles, giving the modern client what they are asking for.

Modern wedding portraiture is a natural, honest approach. Search for intimate, natural moments to capture, and try to achieve the most beautiful and flattering in-the-moment portraiture that you can.

Your business' potential is dependent on your willingness to go the extra mile and tackle new styles . . .

Creating a beautiful wedding album takes creativity and a great deal of experience, blended with modern photojournalism. As you hone your skills for capturing high-impact moments and creating flawless, natural portraits, you will define what "the beautiful wedding" means to you, in your own aesthetic.

Below—Equipment: Canon EOS-1D Mark III with EF 85mm f/1.8L IS USM lens. Exposure: f/2.8 at $^{1}/_{60}$ second and ISO 1000. **Facing page**—Canon EOS-1D Mark III with EF 24–70mm f/2.8L IS USM lens. Exposure: f/2.8 at $^{1}/_{800}$ second and ISO 250.

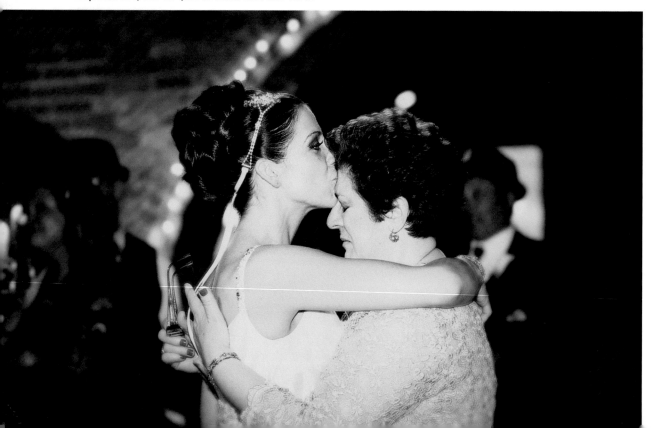

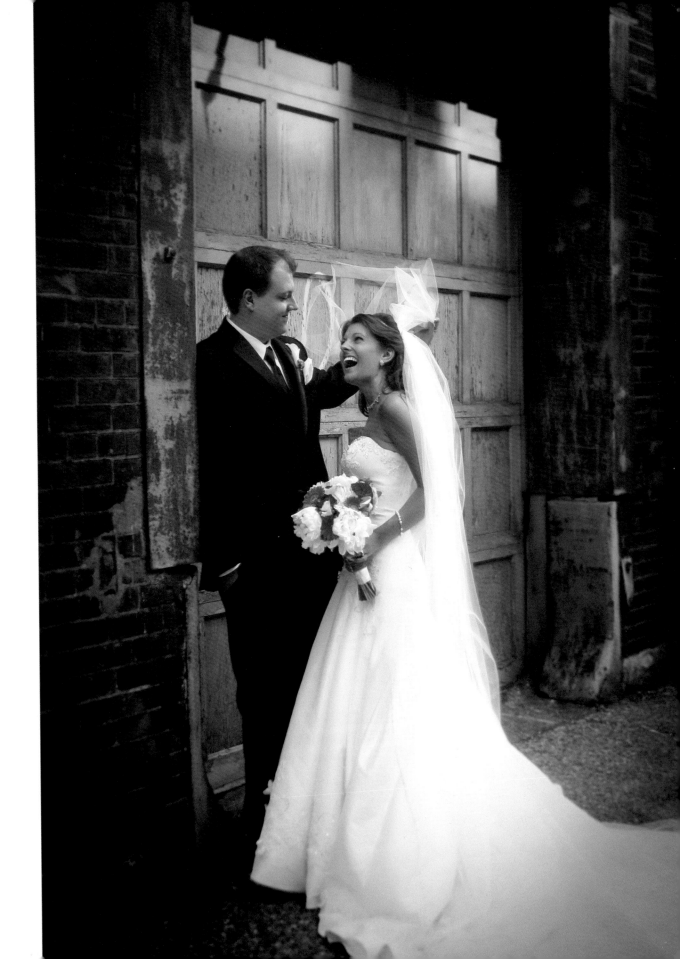

INDEX

A

Accessories, 69
Actions (software), 89
Adobe Photoshop, 88
 See also Postproduction
Albums, 13, 46, 48, 60, 69,
 101, 102, 108–9, 122, 124
Altar, 60
Animals, 27
Aperture, 37, 86, 87
Architectural details, 64

B

Backing up files, 88
Black & white, 37, 90–91
Body language, 40–41, 44, 49
Bonnefoy, Yves, 25
Bouquets. 42, 55, 56–57, 58,
 64, 76, 120
Bouquet toss, 42
Bridal party, 39, 46, 48–49,
 55, 66, 72
 See also Group portraits
Bridal preparations, 48–49
Bride, 6, 10, 12, 13, 17, 28,
 34, 37, 38, 39, 41, 42, 44,
 46, 48–49, 51, 52, 53, 55,
 56, 58, 60, 62, 64, 66, 71,
 72, 73, 75, 76, 78, 84, 90,
 91, 92, 95, 102, 104, 110,
 112, 122

C

Cake cutting, 42
Camera angle, 8, 18, 20, 26,
 28, 36, 37, 44, 46, 76, 84,
 87
Canvas prints, 15, 20, 96, 107,
 110, 111
Cartier-Bresson, Henri, 24–25
Ceremony, 60
Children, 14, 26, 27, 76–77,
 112–23
Chuppah, 60
Close-ups, 51, 52, 53, 56, 59,
 62, 122
Competition, 22, 124
Composition, 36, 84
Couple, photographing, 71
Cropping, 36–37, 84, 92–93
Crowds, 32

D

Decisive moment, 24–27, 36,
 114
Depth of field, 37
Detail shots, 51–65, 109
Diptychs, 20
Discipline, 24, 99
Distracting elements, 8, 46, 88
Distraction, subject, 18, 32,
 116
Dress, 48, 49, 52–53, 55

E

Educating clients, 12
Emotion, 6, 7, 8, 10, 17, 18,
 24, 26, 28, 34, 38–39, 41,
 42, 46, 48, 49, 75, 115,
 120, 121, 122
Environmental portraiture,
 36–37
Equipment, 7, 8, 14, 22, 39,
 46, 53, 76, 80, 86–87, 115
Experimentation, 96, 99
Exposure, 52, 59, 82, 101
Extended family, 78, 122

F

Families, 69, 71, 74, 78, 112,
 122
File backups, 88
Fill light, 82–83, 118
Filters, 88–89
Fine art, 96–99
First dance, 30, 42
First shooter, 10
Flash, 30, 52–53, 80, 82–83,
 87, 118
Flower girl, 76
Flowers, 42, 55, 56–57, 58,
 64, 76, 120
Focus, 26, 27, 30, 31, 34, 59,
 73, 89
Found objects, 64
Frames, 13, 20, 111
Framing (composition), 86

G

Garter toss, 42

Getting ready. *See* Preparations, bride's

Gown, 48, 49, 52–53, 55

Groom, 69

Group portraits, 39, 46, 48–49, 55, 66, 72–73

Growth, professional, 20, 23

H

Heirlooms, 55

I

Interactions, 44

Instincts, 25, 114

ISOs, 82

L

Lenses, 8, 39, 46, 53, 59, 76, 80, 86–87, 115

Location, 120–21

M

Macro, 62

Maid of honor, 75

Mandapa, 60

Mannerisms, 40–41, 44, 49

Materials, 20

 See also Presentation

Monotone images, 37, 90–91

N

Natural light, 80–83

Natural settings, 69, 71

Nervousness, 17, 39, 42, 49, 69

Noise, digital, 82

O

Overexposure, 52, 82

P

Parents, 69, 74–75, 118–19

Peak action, 24–27, 36, 114

Pews, 60

Portrait samples, 13

Posing, 6, 10, 12, 26, 30, 36, 37, 64, 66, 69, 71, 74, 76, 82, 84

Postproduction, 20, 37, 84, 88–95

Practice, 6, 7, 8, 27, 34

Preparations, bride's, 48–49

Presentation, 20, 96

Products offered, 96, 99, 122

Proofing, 99, 101

R

Receiving line, 34, 42

Reception, 32, 42, 62–63

Referrals, 20, 101, 102

Relationship, client, 112, 122

Retouching, 20, 37, 84, 88–95

Ring bearer, 76

Rings, 49, 58

Rule of thirds, 84

S

Sales, 69, 71, 94, 101, 102

Sample portraits, 13

Second shooter, 10

Shoes, 55

Shutter speeds, 25

Simplicity, 8

T

Texture, 52–53

Themes, wedding, 58

Traditional images, 10, 64

Traditional moments, 42

Triptychs, 20

Trust, 13

V

Value, perceived, 88, 107

Variety, portrait, 39

Verbal cues, 38–39, 40

Z

Zoom lenses, 8, 39, 46, 53, 76, 80, 115